DIRECTORS' FOREWORD

Out of Easy Reach is an exhibition that, from its inception, has recognized the gaps and failures of an art system to celebrate, exhibit, honor, or even acknowledge many makers. We have all been deeply committed to lifting the veil to allow the feminist, discursive parts of this system, which we know deeply, to be shared with larger audiences, those with seemingly unsympathetic ears and, even, our own ears. We provide a platform for specific voices that listen to one another, yet long for a more complicated articulation of the self and of otherness. Organizing *Out of Easy Reach* offers DePaul Art Museum, Gallery 400 at the University of Illinois at Chicago, and Rebuild Foundation a chance to understand ourselves better as organizations working against the grain to be more deeply present, even as the complexity of Black and Latinx abstraction hinders ready-made answers, coined commercialism, and conventional outreach.

The rigorous and passionate work of guest curator Allison M. Glenn demonstrates not only the importance of specific attention being given to women artists of color, but also the value of preoccupations, deeply lived vocation, and a spirit of relentless advocacy, which become stalwart pre-conditions to great curatorial craftsmanship and history-making. Allison has thoroughly considered Candida Alvarez, Barbara Chase-Riboud, Maren Hassinger, and Howardena Pindell, who form the enigmatic anchor of the exhibition's premise and offer us the dynamism of their distributed artistic generosity and value. These four women trained, taught, guided, and befriended others and have institutionalized paths that today seem as if they have always been available, though they are still only barely open to women artists of color. While our elder makers continue to trailblaze, brilliant younger artists, including those in this exhibition, have also had profound impacts in the field of abstraction.

DePaul Art Museum, Gallery 400, and Rebuild worked together closely, led by Allison's curatorial vision, to exhibit the innovative paradigms of these artists across multiple sites, with overlapping programs, and a publication documenting this amazing cadre of makers and their art. We salute this exhibition as an attempt to ensure that the artistic contributions of women of color enable room for critical reflections of ourselves and powerful assertions about our respective institutional visions around art and social justice.

Out of Easy Reach is the result of a long process, one that could not have occurred or come to fruition without the dedication of generous sponsors. Without Dedrea Gray, this exhibition would not have happened. Supporting Allison's vision from its earliest moments, De was instrumental in cementing the exhibition's presentation at our three institutions and the guiding force in gathering the amazing group of supporters who make this exhibition and catalogue possible.

So, too, are we grateful to the Joyce Foundation for their major support of *Out of Easy Reach*, through its program to support arts organizations in Chicago and the Great Lakes region. As well, our gratitude goes to the Nathan Cummings Foundation, which provided additional support through a grant with the encouragement of Jane Saks. Many thanks are due for the generous support provided by donors the Dedrea, Paul, and Ian Gray family, Nancy and David Frej, Lisa Yun Lee, James and Paula Crown, Denise and Gary Gardner, Deone Jackman, Jason Pickleman and Leslie Bodenstein, the Bruce and Vicki Heyman Family Philanthropy Fund, Goldman Sachs Gives, Susan and Robert Wislow, Lester Coney, John Ellis, Larry and Marilyn Fields, PATRON Chicago, James Rondeau, the

Chicago Community Trust, Kevann Cooke, Janis Kanter and Tom McCormick, Yumi Ross, Cari Sacks, Jacqueline Stewart, an anonymous donor, Samuel Levi Jones, Tony Karman, and Christopher Audain. The Grunwald Gallery of Art at Indiana University Bloomington provided additional support for this publication.

As the creative powerhouse behind this beautiful catalogue, Otherwise Incorporated has surpassed our expectations. We thank Nancy Frej, Alex Sommerville, and Mary Albright not only for the brilliance of their work but the camaraderie of this team effort. We are thrilled that the exhibition will travel to the Grunwald Gallery of Art at Indiana University in fall 2018 and thank Director and Curator Betsy Stirratt and Assistant Professor Faye Gleisser for their enthusiastic support and financial contribution to this catalogue.

Many thanks to the staffs of our institutions for carrying out this exhibition with grace, finesse, and dedication. At DePaul Art Museum, we thank Mia Lopez, Laura-Caroline Johnson, and Kaylee Wyant; interns Gareth Kaye, Lizabeth Applewhite, and Zoe Krueger; and our student gallery monitors. Thank you to Gallery 400 staff members Erin Nixon, Demecina Beehn, Marcela Torres, Erin Madarieta, Rachel McDermott, Megan Moran, Nate Braunfeld, Kyle Schlie, and Alexandra Schutz, and interns Claire Doonan, Ryn Osbourne, and Liz Vitlin. At Rebuild Foundation, we thank Carris Adams, Sonia Yoon, G'Jordan Williams, Chris Salmon, and Maya Wallace.

Deepest gratitude to Allison for her curatorial foresight, tenacity, and generous collaborative spirit. It has been a pleasure working on this critical exhibition with her. Lastly, many thanks to the brilliant artists for their exquisitely powerful works.

JULIE RODRIGUES WIDHOLM
DIRECTOR AND CHIEF CURATOR, DEPAUL ART MUSEUM

LORELEI STEWART
DIRECTOR AND CURATOR, GALLERY 400, UNIVERSITY OF ILLINOIS AT CHICAGO

THEASTER GATES
FOUNDER AND EXECUTIVE DIRECTOR, REBUILD FOUNDATION

CURATOR'S ACKNOWLEDGMENTS

My life in Chicago, where I lived for almost ten years, was the catalyst for *Out of Easy Reach*. The ideas for the exhibition began there, and many of the artists have a relationship to the city. Some, like Yvette Mayorga and Torkwase Dyson, were born in and around Chicago. Others, like Edra Soto, Steffani Jemison, Lisa Alvarado, Sheree Hovsepian, and Kellie Romany were educated there. Ayanah Moor, Caroline Kent, and Candida Alvarez currently teach at the city's universities and art schools, and many of *Out of Easy Reach*'s artists have previously exhibited in Chicago.

While living in the city, I developed deep and lasting relationships with artists, scholars, and educators who challenged me to think beyond binaries. When I am honest with myself, I realize that this way of thinking has always been a part of my life, and it stems from my formative years growing up in a multiracial family. Making deep connections with the people who helped me to fully realize the potential of this position was crucial to the development of my adult self. While pursuing graduate degrees at the School of the Art Institute of Chicago, I encountered art history professors like Kymberly N. Pinder, whose groundbreaking anthology *Race-ing Art History: Critical Readings in Race and Art History*—and the course she taught with this text—introduced and reinforced an art historical methodology that creates bridges across seemingly siloed art histories. Attending Hamza Walker's lectures and exhibition openings at the Renaissance Society and reading Darby English's *How to See a Work of Art in Total Darkness* count as key moments in the evolution of my curatorial voice.

Watching artists, curators, and scholars do it right was an invaluable opportunity for me. A hugely influential experience was a summer-long graduate internship at the Hammer Museum in Los Angeles, where I had the opportunity to work with Kellie Jones and Naima J. Keith on *Now Dig This! Art and Black Los Angeles* 1960-1980. I first encountered Maren Hassinger through Jones' show, which allowed me to work in the studio with Hassinger to create *A Place For Nature* (2011), which was reconstructed from two sculptures originally exhibited at ARCO Center for Visual Art in 1976. Working from just a photograph of a previous installation, we assembled and tagged each of the many components of the sculpture, taking photographs and documenting the work for the museum's registrars and preparators. During this time, Candida Alvarez was the graduate dean at SAIC, and I spent many afternoons sitting in her studio, talking about painting, career ambitions, and family while working with her on Subterranean Projects, a curatorial project she ran in her former studio at the Fine Arts Building. This exhibition would not be possible without the encouragement that I continue to receive from these dynamic women.

I am extremely grateful to the team that made *Out of Easy Reach* possible. I must first thank Kellie Romany and Dedrea Gray, dear friends and a magical, powerhouse dream team who believed in me and this exhibition before there was even a fully formulated proposal. People like Paul and De Gray make the world a better place, and I'm humbled by their support and generosity. Julie Rodrigues Widholm, Director and Chief Curator of DePaul Art Museum, and Lorelei Stewart, Director and Curator of Gallery 400 at the University of Illinois at Chicago, were truly the backbone of the development of this exhibition. Without their trust and their tireless hours of mentorship, we would have never crafted this idea into a successful collaboration across multiple institutions. I am extremely grateful to Theaster Gates, Founder and Executive Director of Rebuild Foundation, for being an early advocate of my voice and for challenging me to think broadly about site— what it means to make this exhibition in Chicago and how to think critically about audience and location. I am so grateful that Carris Adams stepped in to manage the Rebuild portion of *Out of Easy Reach* and have had such a blast working with her to shape the exhibition there. I am truly grateful to my colleagues Mia Lopez of DePaul Art Museum and Erin Nixon of Gallery 400, who worked very diligently at their respective institutions to contribute to the development of the exhibition and to author multiple catalogue essays. Thank you to Laura-Caroline Johnson of DePaul Art Museum, who developed the touring prospectus for *Out of Easy Reach*, and to the team at Grunwald Gallery of Art at Indiana University Bloomington: Chris McFarland, Erik Probst, Linda Tien, and Betsy Stirratt, for accepting the touring exhibition and developing the art history symposium. The exhibition and symposium at Indiana University are made possible by the New Frontiers in the Arts and Humanities and the College Arts and Humanities Institute. I would also like to thank the Department of the History of Art, the Grunwald Fund, and the School of Art, Architecture and Design at Indiana University. Thank you to the symposium speakers, including keynote speaker Kellie Jones, and speakers Torkwase Dyson, Steffani Jemison, Edra Soto, Julie Rodrigues Widholm, and Lorelei Stewart.

Thank you to all of the galleries and lenders, including David Castillo and Danielle Damas of David Castillo Gallery; Monique Meloche, Aniko Berman, and Allison Moore of Monique Meloche Gallery; Emanuel Aguilar and Julia Fischbach of PATRON Gallery; Raven Munsell of Richard Gray Gallery; Scott Brisco, Michael Jenkins, and Meg Malloy of Sikkema Jenkins & Co.; Marie Catalano and Jasmin Tsou of JTT; Honor Fraser and Emily Gonzalez-Jarrett of Honor Fraser Gallery; Corrina Peipon and Angela Robins, formerly of Honor Fraser Gallery; Galerie Emmanuel Perrotin, Paris; Bridget Donahue Gallery; Bryan Davidson Blue and Rachel Garbade of Garth Greenan Gallery; Whitespace; Halley K. Harrisberg, Hooper Tanner, and Marjorie Van Cura of Michael Rosenfeld Gallery. Thanks to lenders Dr. Daniel S. Berger, Andrew Engel and Jenna Feldman, Eugene Fu, and Scott Hunter.

I am thankful to Charlie Tatum for inviting me to use the space of Pelican Bomb's Art Review to work through ideas for a few of the artist essays and for his keen insight into the development of my essay and this catalogue. And to the inimitable Cameron Shaw, for her laughter, spirit, wisdom, and brilliant ability to capture in her essay the ethos of the "in-between" as it relates to identity, life, and the journey through it all. To Faye Gleisser for her peer review, and phenomenal short-form entries. Special thanks also go to Rachel Adams, Chloë Bass, Rashayla Marie Brown, Torkwase Dyson, Alexandria Eregbu, Kimia Maleki, Emily Wilkerson, Jennifer M. Williams, and Allison Young for their catalogue entries on the artists; to Renaud Proch, María del Carmen Carrión, and Kimi Kitada of Independent Curators International and to all my colleagues who attended ICI's 2016 Curatorial Intensive in New Orleans. I have so much gratitude to the Joyce Foundation, for being early supporters of my participation in the Curatorial Intensive, which solidified the development of this exhibition and for their subsequent funding of this exhibition. Thank you to Rebuild Foundation staff members Elly Hawley, Mallory McClaire, Maya Wallace, G'Jordan Williams, and former employee Jon Veal. I would like to thank all of the funders for believing in this project. Special thanks to the team at Otherwise Incorporated—Nancy Lerner Frej, Alex Sommerville, and Mary Albright—for designing such a gorgeous publication.

Gratitude always to my family and friends for their steadfast encouragement and guidance as I worked toward this ambitious undertaking. Lastly, I would like to thank all the brilliantly talented artists in *Out of Easy Reach*. This exhibition would not be possible without your belief, guidance, and acumen.

ALLISON M. GLENN

IN ALL THE MOVEMENTS OF THE WORLD…WE, THE DESCENDANTS,
WHO HAVE ARRIVED FROM THE OTHER SHORE WOULD BE WRONG TO CLING FIERCELY TO THIS SINGULARITY.

-ÉDOUARD GLISSANT[1]

OUT OF EASY REACH

ALLISON M. GLENN

In his 2008 essay "Towards an Ethics of the Double Entendre," Thomas J. Lax considers the oscillation between familiarity and distance in photographer Leslie Hewitt's body of work *Riffs on Real Time* (2002–09). "Pushed back by a disappearing perspective," states Lax, "the objects and the memories they reference are out of easy reach."[2] From traditional approaches to broader, more challenging usage of the term, *Out of Easy Reach* explores the conceptual expansion of abstraction by American female-identifying artists from the Black and Latina diasporas. Focusing on work made from 1980 to the present, *Out of Easy Reach* presents myriad ways an intergenerational cross section of artists working now are employing abstraction as a tool to explore histories both personal and universal, with focuses on spatial politics, mapping, migration, landscape, the archive, the body, and assemblage.

Out of Easy Reach is an argument for an expansive approach to the traditionally limited conversation around abstraction and contemporary art, and language provides one avenue through which to navigate this discourse. During the 19th and 20th centuries, the language developed to discuss abstraction was primarily focused on formal concerns. Common descriptive terms—such as painterly, gestural, and hard-edged—point to the application of paint, the rendering of imagery, and the relationship between artists and the canvas. These descriptors have been historically used in reference to the practices and processes of a canon of predominately male artists, while often leaving the contributions made by women, particularly women of color, outside of the dominant narrative of art history. In recent years, artists, scholars, and curators have returned to abstraction as a site and device for engaging with both the erasure of difference in the canon and the very politics of effacement by which social hierarchies have been maintained.[3] *Out of Easy Reach* examines the lesser-known creative output of female-identifying artists who use abstraction as a tool to navigate, respond to, and embrace the contemporary world and historical legacies of artistic production. This exhibition enthusiastically moves beyond the highly restrictive space of art history and beyond formal terms by identifying themes and shared aesthetic and conceptual concerns emerging across three generations of artists, whose lives currently span seven decades.

While in the last 35 years there have been exhibitions focusing on black cultural production through the lens of abstraction, the contributions of women of color have been largely ignored. As Erin Dziedzic and Melissa Messina, co-curators of *Magnetic Fields: Expanding American Abstraction, 1960s to Today*, organized by the Kemper Museum of Contemporary Art in Kansas City, state in the introduction

to their catalogue, "the contributions of women artists of color have been at worst completely omitted, and at best undervalued."[4] *Magnetic Fields* highlighted 21 Black and Latina artists—primarily painters, all born between 1891 and 1981—and their groundbreaking artistic contributions. By drawing parallels to the artists' male counterparts, Dziedzic and Messina smartly positioned many of the female artists and their practices in their rightful place within the history of American abstraction and resituated five artists into what they describe as the future course of abstraction. *Magnetic Fields* and *Out of Easy Reach* are both projects of reparative art history, conceived of at the same time, yet tackling and extending the argument for an expanded view in distinct ways. Whereas Dziedzic and Messina laid the groundwork for examining the space of painterly and post-painterly abstraction, *Out of Easy Reach* bridges and strategically emphasizes the efforts of trailblazing women, primarily born in the latter half of the 20th century, whose work defies set notions of abstraction—including the limits of language used to define it.

Out of Easy Reach addresses a crisis of visibility of female-identifying artists of color within the narrative of abstraction's history by connecting multiple generations through a wide temporal framework. The exhibition is thus structured to incorporate four artists—Candida Alvarez, Barbara Chase-Riboud, Maren Hassinger, and Howardena Pindell—whose work has greatly influenced generations of artists who have followed them. For example, Alvarez's consideration of the landscape, and the impact of history and culture on place; the monumental scale and materiality of Chase-Riboud's sculptures; and Hassinger's interest in sculpture, the body, and performance have directly or indirectly informed the work of younger artists like Caroline Kent, Shinique Smith, and Juliana Huxtable, respectively. Similarly, Adrian Piper and Senga Nengudi, though not included in *Out of Easy Reach*, hover around the exhibition as catalysts for contemporary artists. Their early experiments in performance and, specifically, Piper's theoretical contributions to art history, philosophy, and performance studies have shaped multiple generations, evident in Ariel Jackson's *Origin of the Blues* (2015), Huxtable's *Untitled (For Stewart)* (2012), and Pindell's *Free, White and 21* (1980).

ABSTRACTION: FREEDOM AND TIME

Out of Easy Reach considers how women from two proximal generations have been informed by those before them. The exhibition takes 1980 as a starting point, a murky crossroad, the intersection of what are now commonly called

1 Manthia Diawara, "One World in Relation: Édouard Glissant in Conversation with Manthia Diawara," *Nka* 2011, no. 27 (2011), 4–19.

2 Thomas J Lax, "Towards an Ethics of the Double Entendre," *New Intuitions: Artists in Residence 2007-2008* (New York: Studio Museum in Harlem, 2008).

3 Recent exhibitions of note include *Revolution in the Making: Abstract Sculpture by Women*, 1947-2016, co-curated by Paul Schimmel and Jenni Sorkin (Hauser Wirth & Schimmel, Los Angeles, 2016); *The Women of Abstract Expressionism*, curated by Gwen Chanzit (Denver Museum of Art, 2016; Mint Museum, Charlotte, 2017; and Palm Springs Art Museum, 2017). A selection of additional exhibitions of interest, in chronological order, begins in the early 1980s: *Afro-American Abstraction*, curated by April Kingsley (Institute for Art and Urban Resources, New York, 1980; Los Angeles Municipal Art Gallery, 1982); *Frequency*, curated by Christine Y. Kim and Thelma Golden (Studio Museum in Harlem, New York, 2005); *Double Consciousness: Black Conceptual Art Since 1970*, curated by Marti Mayo and Valerie Cassel Oliver (Contemporary Arts Museum Houston, 2005); *Energy/Experimentation: Black Artists and Abstraction, 1964-1980*, curated by Kellie Jones (Studio Museum in Harlem, New York, 2006); *Black in the Abstract, Part 1: Epistrophy* and *Black in the Abstract, Part 2: Hard Edges/Soft Curves*, curated by Valerie Cassel Oliver (Contemporary Arts Museum Houston, 2014); and *Rites of Spring*, curated by Dean Daderko (Contemporary Arts Museum Houston, 2014).

4 *Magnetic Fields: Expanding American Abstraction, 1960s to Today*, ed. Erin Dziedzic and Melissa Messina (Kansas City: Kemper Museum of Contemporary Art, 2017), 14.

Generation X and the Millennial generation.[5] This generational classification is based on transformations in a few key social factors—technology, access to information, and world affairs.[6] Following the figures of Alvarez, Chase-Riboud, Hassinger, and Pindell, ten of the artists in *Out of Easy Reach* were born as part of Generation X and ten were born as part of the Millennial generation, in and amongst a slippery landscape of shifting language, identities, and nation-states.

These complex political and generational shifts are also apparent in some of the artists' relationships to time. When viewed collectively, the practices of Hewitt, Hovsepian, Jackson, Kent, Abigail DeVille, Jennie C. Jones, and Xaviera Simmons clearly share a philosophical relationship to nonlinear time, resisting the traditional understanding of history as a successive series of events linked by cause and effect. DeVille's *I am invisible, understand, simply because people refuse to see me* (2014) includes a mirrored structure leaning against two CRT televisions that are turned on but not connected to a channel. The static that emanates from the analogue television evidences traces of the cosmic microwave background from the Big Bang, collapsing time through material. Jackson's accumulation and juxtaposition of found footage in *Origin of the Blues* and Hewitt's flattening of the past and present in *Riffs on Real Time (10 of 10)* (2008) disrupt the impulse toward understanding time as an easily analyzed, linear succession of events. Kent's unique painted abstractions, such as *Procession* (2015), conflate Romanian phonology, architecture, and topography into unstretched canvas paintings and works on paper. Simmons takes a sculptural approach to history, as in *On Sculpture #2* (2011), which delicately maps an old black-and-white photograph onto a contemporary horizon line.

INTERSECTIONALITY AND THE RHIZOME

In 1989, Kimberlé Crenshaw introduced the notion of intersectionality, a concept for discussing identity and the myriad ways that genetics, the environment, and society form an individual.[7] Echoing her iconic essay, Crenshaw explained in a 2017 public lecture that "intersectionality is a framework" and used the metaphor of the intersection of two or more roads to create a scaffold, through which one can understand the composite that is any one person.[8] Proximal developments in postcolonial theory occurred around the time of Crenshaw's theorization, including Édouard Glissant's use of the rhizome as a form to discuss identity formation. Glissant's rhizome exists as a sublime space where experiences become enmeshed and connected. This networked arrangement breaks history's grand narrative, stifles the "predatory rootstock" of a fixed mind state that is unable to shift, and challenges traditional linear forms in favor of ones that are much more open and fluid.[9] The emergence of the rhizome as a way to visualize a shift in language and perspective speaks to the global interconnectedness definitive of 21st-century citizenry. The idea of a constantly renegotiated subject position understood through relations to others allows language to be deployed in service of more expansive conceptions of self.[10]

5 See "The Whys and Hows of Generations Research," *Pew Research Center*, September 3, 2015, http://www.people-press.org/2015/09/03/the-whys-and-hows-of-generations-research/. Though the point where Generation X ends and the Millennials begin is debatable, a 2015 study by the Pew Research Center recognizes Generation X as those born from 1965 to 1980, and the Millennial generation as anyone born from 1981 to 1997.

6 See Rebecca Onion, "Against generations," Aeon, May 19, 2015, https://aeon.co/essays/generational-labels-are-lazy-useless-and-just-plain-wrong. Though many writers and theorists support this division and naming of generations, many oppose generational thinking altogether.

7 Kimberlé Crenshaw, "Demarginalizing the Intersection of Race and Sex: A Black Feminist Critique of Antidiscrimination Doctrine, Feminist Theory, and Antiracist Politics," *University of Chicago Legal Forum* 1989, 139–67.

8 Kimberlé Crenshaw, "The Intersectional Paradigm: Race and Gender in Work, Life and Politics," public lecture at Tulane University, New Orleans, September 25, 2017.

9 See Édouard Glissant, *Poetics of Relation*, trans. Betsy Wing (Ann Arbor: University of Michigan, 1997). Martinican author and poet Édouard Glissant builds upon the rhizomatic form first introduced by philosophers Gilles Deleuze and Félix Guattari in *A Thousand Plateaus* (1980), which presented the rhizome as a non-hierarchical structure through which the structure of an individual's personal and collective history is developed.

10 To give an example, quite a monumental paradigm shift is one disrupting gender, allowing for a person to identify as a woman, a man, or as a non-binary subject, expanding the space of gender identity and gender expression to encompass positions not wholly within one category, but instead liminal and uncategorizable.

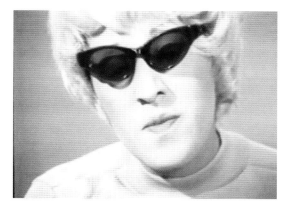

Howardena Pindell, still from *Free, White and 21*, 1980. Color video with sound, 12 minutes 15 seconds.

With these ideas at its core, *Out of Easy Reach* abandons art historical narratives that routinely silo artists through categorization and fail to consider these intersections; the exhibition instead moves into, and cultivates, a space of multiplicity. In Chicago, artworks are grouped at three separate institutions based on themes that provide starting points for critical engagement. Gallery 400 at the University of Illinois at Chicago includes artists and artworks with conceptual concerns relating to spatial politics, mapping, and migration. DePaul Art Museum presents artworks that use the lens of history to engage with landscape, the body, and the archive. Time, process, and material culture are resonant themes explored through assemblage practices at Stony Island Arts Bank. While it is useful to group artists into these subheadings, clear affinities abound across categories.

SPATIAL POLITICS, MAPPING, AND MIGRATION

Amidst a current global turn toward nationalism and the United States' ever-increasing exclusionary international relations, artists who explore spatial politics and their bodies in relation to borders and the built environment are opening avenues for rethinking narratives around ownership and access. As a country comprised of Indigenous populations and individuals who, at one point or another, were brought here by force or by choice, the U.S. will always face infrastructural biases related to immigration, land use, and policymaking. These are considerations of *Out of Easy Reach* at Gallery 400.

In 1980, Howardena Pindell created *Free, White, and 21*, a 12-minute video that exposes and interrogates the various ways stereotypes are projected upon one's physicality and how identities are overdetermined based on racialized and gendered assumptions. Pindell roots her video's critique in a larger dialogue about class-, gender-, and race-based privilege. Throughout the video, Pindell alternates between the oppressor and the oppressed, assuming two character subject positions, allowing the artist to perform, re-perform, highlight, and interrogate microaggressions that she and her mother have experienced. Pindell's narrative style encompasses both the artist's recollection of aggressions and her perspective of the aggressor. In a portion of the film, Pindell recollects a traumatic experience as a guest at a wedding. The camera sharply cuts from the artist to her performance as a blond-haired white woman with cat-eye sunglasses. "You really must be paranoid," she asserts, "I hear your experiences and I think, well, it's gotta be in her art, that's the only way we'll validate you. It's gotta be in your art in a way that we consider valid…if the symbols are not used in a way—that we use them, then we won't acknowledge them. In fact, you don't exist until we validate you."[11] Pindell's antagonist is the dominating voice, similar to that of the Western canon, which "cancel[led] and rewr[ote] history in a way that made one group feel safe and not threatened."[12]

In his influential text *In the Break: The Aesthetics of the Black Radical Tradition*, Fred Moten uses Adrian Piper's performance practice as an opportunity to critique Michael Fried's relationship to the visual arts. Moten argues "quality and value… exist [for Fried] only in the individual arts and not in their in-between, which is theater." Within the text, Moten notes that the convergence of the "object, person, commodity, artist, and artwork," or theatricality, so commonly found in Piper's performance practice, is a tactic the artist uses to "critique racial categories."[13]

11 Howardena Pindell, "On Making a Video—Free, White and 21," in *The Heart of the Question: The Writings and Paintings of Howardena Pindell* (Midmarch Arts Press: New York, 1997), 69.

12 Ibid.

13 Fred Moten, "Resistance of the Object: Adrian Piper's Theatricality," in *In the Break: The Aesthetics of the Black Radical Tradition*. (Minneapolis: University of Minnesota, 2003), 234.

While Moten's reading is specific to Piper's practice, the theory can be extended to include the performance practices of Pindell and others in *Out of Easy Reach*.

In *Free, White and 21*, Pindell employs the theatricality of performance through costuming, storytelling, and a changing mise en scène. Though this film is unique in Pindell's oeuvre, it is integral to *Out of Easy Reach* for several reasons. As the oldest work in the exhibition, it acts as an anchor, bridging the performance practices of the 1970s and '80s with those of younger artists such as Juliana Huxtable, who extends Pindell's critique of visual singularity. Huxtable uses language, photography, and performance to explore the construction of narratives and her body. Charting the topography of her desires, Huxtable uses freely flowing language, amalgamating seemingly disparate ideas. Combining Moten's conception of the "visual pathology of racist categorization"[14] with that of gender categorization, Huxtable expands the understanding of the problematic pathologies of race and gender together, in the way that Pindell expanded them regarding race. Using her body as a site, Huxtable creates photographs and nonlinear, text-based works—arguably performance scripts—to present a subject position that sits alongside, but outside of, what has been determined to be normative, extending Pindell's objectification of the self as a way to subvert the cisgender gaze. *Nuwaub Chair* (2012) is a photograph of the artist—nude except for head-to-toe chromatic ombré body paint, combat boots, and a necklace— standing on a table. In this photograph, Huxtable imagines herself as a follower of the Nuwaubian Nation, a radical religious sect that combined Judeo-Christian and esoteric beliefs. Locking her eyes on the viewer, Huxtable requires the viewer to engage with her gaze.

Within Lisa Alvarado's fringed and draped paintings, shamanistic tradition collides with a critical inquiry of cultural appropriation and assimilation. Alvarado adorns the surfaces of her mixed-media works with stair-shaped, geometric forms often sourced from the history of spiritual and sacred traditions of less visible cultures, such as Peruvian and Mexican textiles and Taoist magical talismanic practices.[15] These repeated, brightly colored motifs form rhythmic patterns that vibrate on the canvas, aided by her seductive juxtapositions of color on a rich, matte ground. Alvarado's banners function both on their own as paintings and in concert with sound, activated by the experimental jazz group Natural Information Society, of which Alvarado is a member. During performances, the paintings act as backdrops for the group.[16] Within the gallery space there is a reveal, as the paintings, suspended from the ceiling, are meant to be viewed from both sides. This shifting, fluid presentation beckons the viewer to engage with them in the round as one would a sculptural object.

Yvette Mayorga and Torkwase Dyson map the movement of bodies through policies enacted onto them. Dyson's ever-evolving practice examines how sites hold history and meaning. At first glance, Dyson's monochromatic *Auction Block* drawings (2015–ongoing) appear as austere geometric abstractions, meditations on time and space through composition. Delving further into the work, it becomes clear that through the usage of curvilinear marks and brush strokes, Dyson is employing the language of landscape architecture, deconstructing images of slave-auction blocks into abstract forms. At the School of Art and Art History and the School of Architecture at the University of Illinois at Chicago, Dyson's mobile Studio South Zero, developed from a solar-powered mobile studio that Dyson produced during a 2012 Chicago residency at Dorchester Projects, invites collaborations with students and faculty, carving out a space that utilizes history and contemporary art as avenues to question modes of thinking about architecture and the built environment.

Informed by the politics of border-crossing and transnational narratives, Mayorga employs tropes of celebration to investigate race, identity, gender, and Latinx stereotypes. Mayorga's *Monuments* (2014–15) are homages to individuals in the form of deconstructed tier cakes. Highly ornate ribbons of frosting, akin to those which might be found on a quinceañera or birthday cake, adorn the anthropomorphic works from the artist's *Borderlands* series. Mayorga's use of tier cakes is a comment on cultural assimilation, as, according to the artist, they are tied to a hybrid, Mexican-American tradition.[17] Conflating celebration with the

Juliana Huxtable, *Nuwaub Chair*, 2012. Color inkjet print, 8x10 inches (20.32 x 25.4 cm).

politics of immigration, Mayorga's "living shrines to real-life individuals" critique the idea of the American Dream.[18] The thick, gooey surfaces of these bricolage sculptures, which teeter to the point of almost falling over, come to life inside Mayorga's maximalist, room-sized installations, such as *Really Safe in My Room* (2016), *Make America Sweet Again* (2017), and *Welcome to America* (2016), Mayorga's use of formal devices, such as fencing and floor treatments, restricts the viewer's access. This delineation of space is a similar strategy that Pepón Osorio uses in his work, which he describes as designating "these very specific spaces and very specific issues as sacred spaces."[19]

Both Zipporah Camille Thompson and Martine Syms amass and deconstruct cultural signifiers. In *prismatic root* (2015), Thompson carefully maps bundles and coils of hair, along with animal fur and woven textiles, onto a vibrant, pistachio-colored, five-sided shape painted directly onto the wall. Thompson's taxonomic arrangement of hair—specifically the meticulous categorization of twists, cords, braids, and ropes of many different colors—evokes the practices of artists including Ellen Gallagher and Carrie Mae Weems. Working across disciplines— including film, photography, publishing, and digital media—Syms' conceptual practice centers around mapping representations of race and gender within the digital realm. Fences, colloquial phrases ("I want to stay in the cut"), skylines, and headlines found in the series *More Than Some, Less Than Others* (2014–16) point to the major metropolises, like Chicago and Los Angeles, that were impacted by Southern migration to the North and West in the early 20th century.[20] Similar to Thompson's work, Syms' formal decisions rely on repetition. The photographs that comprise *More Than Some* double as movie posters for Syms' *Lessons* (2014– ongoing), a series of short videos that are informed by the Black literary tradition, looking to authors such as Zora Neale Hurston and Kevin Young.

THE ARCHIVE, THE BODY, AND THE LANDSCAPE

The confluence of artistic practices that investigate the archive, landscape, and the visibility of the body is *Out of Easy Reach*'s focus at DePaul Art Museum. This section of the exhibition includes a group of artists who mine histories of abstraction and Modernism, relating them to the representation of the self and the environment.

Kellie Romany's *In an effort to be held* (2016), is comprised of 300 palm-sized, oil-paint-lined ceramic vessels filled with various flesh-colored pigments. Color collects at the center of each concave sculpture, forming ripples and ridges at the edges that recall the fragile fleshiness of the body. Within her larger painting practice, Romany problematizes the widely disputed and ultimately abandoned skin-classification scale created by Felix von Luschan.[21] Brenna Youngblood uses found materials—such as flattened Coke cans, a box of Bounce laundry detergent, and wood paneling—to collapse the space between painterly abstraction and Pop Art. *Untitled* (2012) includes a thin red line that looks like a zipper running diagonally across the top left of the canvas. The composition resembles the aerial view of a landscape, the topography of which is interrupted only by this delicate mark. Youngblood's *Untitled* is visually similar to Candida Alvarez's *Chill* (2011)—a

14 Ibid., 234. This switch employs what Moten identifies in Adrian Piper's performance practice as tracing "the boundary between critical philosophy and racial performance…in order to critique racial categories and to investigate what happens when the visual singularity of a performed, curated, or conceptualized image is deployed in order to move beyond what [Piper] calls the 'visual pathology' of racist categorization."

15 Lisa Alvarado, personal conversation, September 17, 2016. One source referenced by the artist is Laszlo Legaza's *Tao Magic: The Chinese Art of the Occult* (1975).

16 I've had the opportunity to be in conversation with Lisa Alvarado since 2013, a key moment at which the artist began to understand her paintings as more than performance components but also as objects in their own right.

17 Yvette Mayorga, personal conversation, July 26, 2016.

18 Yvette Mayorga, artist statement, accessed November 27, 2017, https://www.yvettemayorga.com/about/.

19 "Place," *Art in the Twenty-First Century* (New York: Art21, 2001), https://art21.org/watch/art-in-the-twenty-first-century/s1/pepon-osorio-in-place-segment/.

20 Martine Syms, personal conversation, September 20, 2016.

21 Kelly Romany, in conversation with Romi Crawford at the Arts Incubator at the University of Chicago, May 19, 2013, http://www.kellieromany.com/#/gestate-installation-1/.

Bethany Collins, *Southern Review, 1985 (Special Edition)*, 2014-15. Charcoal on paper (64 pieces), 57 1/2 x 104 inches (146.05 x 264.16 cm) overall.

cool-toned canvas punctuated by thick, goopy lines of paint—and the surface of Jennie C. Jones' *Grey Measure with Clipped Tone (Inverses)* (2016). Within her often-minimalist practice, Jones has an ongoing interest in the restructuring of Modernist narratives, with a keen focus on those who were excluded from the conversation. Taking mid-20th-century musical histories as a point of departure, Jones combines these accounts with materials used in recording and sound booths—such as acoustic absorber panels—and distinct marks that recall sound waves.[22] The artist also creates sound works; and at times the two modalities reference each other.

For Ariel Jackson, Steffani Jemison, Bethany Collins, and Ayanah Moor, the archive is an endless source of inspiration. Jackson's *The Origin of the Blues* is a para-fictional video work that reflects on the artist's coming of age in New Orleans during Hurricane Katrina through an investigation of mass-media representations during the aftermath of the storm. Here, Jackson has combined archival video footage appropriated from sources as varied as a 1968 CBS News special "Black History: Lost, Stolen, or Strayed," which was produced and hosted by Bill Cosby; police cameras; and old films with voice-over narration by the artist's performative alter ego, a character Jackson refers to as Confuserella.[23] Through the fracturing and re-presentation of the media alongside a soundtrack of '60s and '70s music, Jackson unhinges a linear, one-dimensional narrative of post-Katrina New Orleans. The artist uses the "blues" to identify the complexities of loss. Jackson's ultimate goal, it seems, is to find the blues—where they originate and how they manifest—to have an expanded understanding of herself.

Jemison's *Same Time* (2016) consists of two large sheets of transparent plastic, propped-up and supported by long white plinths. The thick, black curvilinear shapes printed on the sheets' surfaces are taken from the sketchbook diary of James Hampton, a self-taught artist who dedicated his life to building a sculpture he titled *The Throne of The Third Heaven of the Nations' Millennium General Assembly* (c. 1950-64).[24] Hampton also created a personal lexicon of meticulously recorded symbols, glyphs, and marks to become the language of his own ministry. The marks on these transparencies are an abstraction of these symbols, and they remain indecipherable, unable to be read. This impossibility is articulated through both the abstracted shapes and forms and Jemison's repeated use of the title *Same Time* throughout her practice, a fact that presents inherent challenges to the cataloguing of each work.

In *Southern Review, 1985 (Special Edition)* (2014-15), Collins achieves illegibility through the redaction of large sections of the titular edition of the literary journal—a self-correcting issue that attempted to address the historical lack of representation of diversity within its contributors by only publishing essays and artwork by people of color. Thick charcoal marks cut through pages of the journal, which are hung in a grid-like pattern. The act of obfuscation heightens the viewer's awareness of absence and invisibility. With *Good News* (2011), Moor queers an article titled "What They Say about the Men in Their Town" from the September 1980 issue of *Ebony* magazine. This section was taken from a larger feature titled "Where are the Eligible Black Men?", which charted the contemporary dating scene from a female perspective. Within this project, Moor edits the quote for length, shifts the speaker's gender, and alters their name. One testimonial, from a woman named Beryl Turner, regarding available men in New Orleans begins: "There's no husband material in New Orleans. There are just no good prospects…most of the men want more than one woman…."[25] In Moor's version, Berylee Turner's testimonial is as such: "There's no wife material in New Orleans. Most of the women want more than one woman…." Through the deletion of sentences and the switching of subject pronouns in each of the testimonials, Moor cleverly shifts the archive, reflecting the lack of representation of the queer, feminine gaze in popular media.

Artists Maren Hassinger and Edra Soto use their work to deconstruct architectures of power. Hassinger's interdisciplinary practice often considers performance and corporeal objects. To form each fragment in her cumulative sculpture, *Fight the Power* (2016), Hassinger rips and crumples pieces of paper that have the title phrase written on them, twisting the shreds of paper around one another to create an interconnected, repetitive form. The artist's presentation of mangled protest signs comes at a time when the U.S. is deeply entrenched in demonstrations against police brutality, for and against monuments to the Confederacy, for the protection of women's rights, and for one's right to identify however one wishes, amidst an increasingly aggressive and unforgiving public sphere. Placement is everything for Hassinger, and *Fight the Power* is meant to hang above eye-level, like a frieze in a Greek temple,[26] a space commonly reserved for triumphant allegorical narratives. Symbolism and repetition form the foundation of Soto's *Graft* project (2013–ongoing), which considers the migration of ornate iron fences, or *rejas*, found on the façades of many working-class shotgun homes, Creole cottages, and middle-class dwellings in Puerto Rico.[27] Since 2013, Soto has been using the form of the rejas to create various interventions in personal and public spaces by recreating the decorative iron screens and deconstructing the loaded history of colonial architecture in the Caribbean.[28] The physical structures become a vehicle for conversation about colonialism's insidiousness and the extent to which contemporary cultural appropriation arguably stands in its legacy. The *rejas*, a product of Spanish rule, are designed to keep certain people in and others out. But their beautifully ornate designs aestheticize and obscure this true exclusionary intention. Relying on a similar tension, Soto subtly critiques systems that might perpetuate distinct—but arguably misplaced—boundaries between public and private.

ASSEMBLAGE

There is a rich history of assemblage practices that inform and are informed by ideas around abstraction, building on the historic practices of artists like John Outterbridge, Betye Saar, and Joan Mitchell. At Stony Island Arts Bank, *Out of Easy Reach* extends that history to include artists that entwine time, literature, and material culture in dynamic, cross-disciplinary works.

22 Jennie C. Jones and Valerie Cassel Oliver, public lecture at Contemporary Arts Museum Houston, accessed November 5, 2017, https://youtu.be/XX9eru9hGVM.

23 Ariel Jackson, personal conversation, October 1, 2017.

24 See "The Throne of the Third Heaven of the Nations' Millennium General Assembly," Smithsonian American Art Museum, accessed November 25, 2017, https://americanart.si.edu/artwork/throne-third-heaven-nations-millennium-general-assembly-9897. Hampton's Throne is a highly intricate and profoundly ornate assemblage, which the artist created by wrapping in gold and silver foil items found in federal office buildings in Washington, D.C., where he worked as a janitor.

25 "What They Say about the Men in Their Town," *Ebony*, September 1980, 40.

26 Maren Hassinger, personal conversation, October 5, 2017.

27 Albert Stabler, "Introduction, Graft, (Chicago: Sector 2337, 2017), 4.

28 The project was first presented on the façade of a private home in Oak Park, Illinois, where artist and educator Sabina Ott runs the independent exhibition space Terrain Projects. One of *Graft*'s more fleeting iterations included an appearance on the interior of the Arts Club of Chicago, where—for the club's 100-year anniversary—Soto adhered patterned vinyl for one weekend to the interior windows that separate the public exhibition space from the private, members-only club on the second floor. In 2017, Soto returned to the Arts Club to realize Screenhouse, a metal "social structure", as the artist refers to it, built from sintra and metal in the Club's garden space.

Sheree Hovsepian's practice finds its root in analogue photographic processes, such as photograms, which are photographs made by using objects to block light from reaching photo-sensitive paper, creating abstracted images that operate as indexes of the darkroom and studio. With *Reveries of a Solitary Walker* (2015) Hovsepian, building on her photogram experiments, began to create multimedia works from items she found in her studio. *Reveries of a Solitary Walker* is a string assemblage created atop a photographic composite of pin-pricked paper. The sheen from thick lines of graphite flows from the top of the composition, bisected by a remnant of burnished wood. String looped around brass nails forms a constellation of geometric shapes. Photograms of varying sizes, as well as gestural ink and walnut-oil drawings are collaged on the delicate surface. More recent works such as *Sway* (2017) and *Lotus Position* (2017) include photograms with nylons stretched across their surface, displaying a wide range of influences from László Moholy-Nagy to Senga Nengudi. And Hovsepian's *Peaking* (2015) bears a striking likeness with Barbara Chase-Riboud's *Little Gold Flag* (1985), a silk and polished-bronze sculpture also included in *Out of Easy Reach*.

Hovsepian, who was born in Iran and grew up in the United States, at times includes in her works textiles and macramé, a weaving technique she learned from her mother. While the etymology of the French word "macramé" is disputed—it can be traced to both the Arabic word *migramah* or *mikrama*, which was associated with weaving practices in the Middle East, and the Turkish word *makrama*—the origin of the technique of macramé can be traced back to the North Africa, plausibly moved to Iran through the Afro-Iranian slave trade.[29] This history makes Hovsepian's works a natural fit for *Out of Easy Reach*, and complicates traditional narratives around the African diaspora, as Hovsepian identifies as Iranian.

Chase-Riboud began making monumental sculptures in 1958, utilizing the lost-wax technique that has become a signature part of her process.[30] That same year, she met novelist Ralph Ellison in Rome and graced the cover of *Ebony* magazine—the only visual artist to have been featured on the cover of the publication.[31] Chase-Riboud weaves her poetry and sculpture practices together through language, and indeed, much of her poetry references her rendered forms. For example, the name Pushkin—a reference to the famous poet—appears both as the title of a sculpture made in 1985 and in her poem "Akhmatova's Cenotaph." The poem's title refers to the Russian poet Anna Akhmatova, who penned numerous scholarly essays on Alexander Pushkin.[32] Perhaps Chase-Riboud, who has spent the majority of her life living abroad in Europe, identifies with Akhmatova's adept use of language, incredible brilliance at a young age, and self- and state-imposed exile. Chase-Riboud herself showed great promise at a young age: Her literary work "Of Understanding" was read at her high school commencement, and the Museum of Modern Art acquired one of her artworks before she completed her undergraduate studies.[33]

In *Out of Easy Reach*, Chase-Riboud's monumental *Little Gold Flag* also incidentally creates conversation with works by Shinique Smith. It wasn't until after plans were made to place works by Chase-Riboud and Smith together at Stony Island Arts Bank that Smith recalled meeting Chase-Riboud at the Walters Art Museum in Baltimore, where Smith worked, in 2000. Smith's "experience of working at that museum, [with] an intimate relationship to the Asian, Egyptian, African, and decorative collections and seeing Chase-Riboud's work amid those objects was deeply affecting."[34] Each of the braided strands in Smith's monumental sculpture, *Forgiving Strands* (2014-18), is created from found textiles. The strands are combined with spherical bunches of fabric that cascade into the exhibition space on the first floor of the galleries in response to the surrounding interior architecture. A version of *Forgiving Strands* was included in the monumental 2016 exhibition *Revolution in the Making: Abstract Sculpture by Women, 1947-2016*, curated by Paul Schimmel and Jenni Sorkin, at Hauser Wirth & Schimmel (now Hauser & Wirth) in Los Angeles. In that exhibition, Smith's gorgeous, bulbous forms draped along a corridor between two buildings, the colors and shapes splendidly

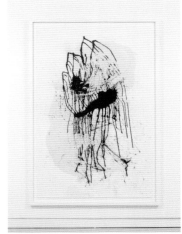

Sheree Hovsepian, *Peaking*, 2015. Ink and walnut oil on paper, 85 1/2 x 58 1/2 x 1 1/4 inches (217.2 x 148.6 x 3.2 cm).

contrasting with the texture and color of the walls, recalling Outterbridge's *The Rag Factory* (2011), an installation at LAXART that included a site-specific sculpture of knotted rags vertically hung from the center of the ceiling in the main gallery.

The lines within Smith's paintings and her sculptural forms are seemingly interchangeable; in her practice, the artist easily transitions from rendering depth in two-dimensions to producing three-dimensional objects in space. As curator Valerie Cassel Oliver writes, Smith's sculptures move "past the dialogue about painting through the integration of bundles of fabric."[35] When viewed alongside her sculptures, the sketch-like quality of Smith's paintings, although fully developed objects in their own right, suggests that they are plans for realizing their true sculptural forms. The bundles of fabric are the marks, and the entire space in which the sculpture exists becomes the composition.

FUTURE DISCOURSE AND DIALOGUES

Out of Easy Reach begins as it ends, with a set of ever-shifting questions, concerns, and ideas. How do we define abstraction, and, quite specifically, how can shifting, abstracted subject positions assert marginalized perspectives alongside, in dialogue with, and in response to dominant art historical narratives? Although *Out of Easy Reach* is constructed through the categorization of artists based on gender and race, it does not rely on this limiting practice, which so often appears in art history, to constrict critical investigation. After all, race itself is a social construct, an abstraction.

While some of the artists in *Out of Easy Reach* are deeply invested in conversations centered on the body, as is most evidenced in the work at Gallery 400, others explore more formal concerns, like those on view at Stony Island Arts Bank. At DePaul Art Museum, questions emerge through a critical investigation of archives and landscape and how these consider, record, and impact individuals. Ultimately, abstraction is central to each of the 24 artists, albeit in differing ways.

This exhibition is a beginning—a platform—onto which aligning or diverging critical investigations can be built. To contribute to broadening the discourse around abstraction in contemporary art, *Out of Easy Reach* includes commissioned essays on each of the artists in the exhibition. In the pages that follow, readers will encounter texts from a variety of contributors, including artists, art historians, curators, and writers. Because the texts are written from multiple perspectives, an allowance is made for subtle variances in essay form, length, and content. From Rashayla Marie Brown's performative piece on Howardena Pindell to art historian Faye Gleisser's clever read on Martine Syms' practice, the entries take the shape of familiar art-historical readings and nontraditional texts. The reader will also notice differences in language used to describe racial identity, gender, and ethnicity. Instead of subscribing to one, generalized style guide, the catalogue addresses its subject from multiple perspectives, keeping with the expansive ethos of the exhibition.

29 In 2016, German-Iranian photographer Mahdi Ehsaei published *Afro-Iran*, a monograph of photographic portraits documenting a population of African-Iranians in Southern Iran who are the descendants of both African slaves and African slave owners. The lush color photographs detail this less visible part of Iranian culture that was influenced by the African diaspora.

30 John Vick, chronology in Barbara Chase-Riboud's *Everytime a Knot is Undone, A God is Released* (New York: Seven Stories Press, 2014), 379.

31 Ibid.

32 "Anna Akhmatova," Poetry Foundation, accessed November 27, 2017, https://www.poetryfoundation.org/poets/anna-akhmatova.

33 Vick in *Everytime a Knot is Undone*, 379.

34 Shinique Smith, personal conversation, October 3, 2017.

35 Valerie Cassel Oliver, "Art of the Refrain" in *Outside the Lines* (Houston: Contemporary Arts Museum Houston, 2004), 101.

WADE ON IN
CAMERON SHAW

As I age, I find myself increasingly interested in the in-between. Perhaps it's because it is the place I've long inhabited, and not necessarily by choice. In the United States, we live in a country of black and white, where my particular shade of brown puts me in the grey. I've become used to the regular invasive questioning of my origins by complete strangers. I've grown numb to the erotic projections of my "exotic" otherness. I've made peace with the countless knee-jerk dismissals, the thinly veiled debasements, and the outright rejections of my right to identify. It took me damn near 35 years in this body—its green eyes, its downy blond hairs, its mop of ringlets—but I've come to understand it as a privilege. I don't use that word here to convey the sense of opportunity afforded to a light-skinned woman by colorism under white supremacy (though I recognize that distasteful truth), but rather to articulate the expansive, fluid potential of the in-between as a locale, one that is ultimately difficult to map or pin down. In the binary of here or there, the not-quite-anywhere might just be everywhere.

In growing into an understanding of this potential and of my body as its site, I've also grown interested in how various other bodies perform the navigation of their own topographies. When do I tell you who I am, what I am, where I am from, so you might orient yourself with greater comfort and ease? And when do I let you wade into my murky in-between with your assumptions as your guide? And, more critically, what can this naming of the in-between teach us as we learn to live with others and ourselves at a time when many are so hell-bent on one-sidedness?

I'm drawn to imagine the in-between as a place precisely because of the other associations place can conjure. The map is a particularly powerful metaphor because a map is itself inherently abstract, in-between by definition. A map signifies a place but it is not the place. It is simply the means by which we might gain perspective on the place, understand how to move when we are in the messy process of actively navigating our unknowingness of it.

In her book *Emergent Strategy: Shaping Change, Changing Worlds*, adrienne maree brown offers a description of how her family's multiracial background—her own in-betweenness—in part nurtured her adaptability and her propensity for facilitation, consensus-building, and mediating work: "navigating other peoples' regressive, fearful, or exoticizing ideas about our identities is one of the ways each member of my family grew this skill set of being able to see what's between, what connects the things that seem to separate the ever-present whole."[1] That description rings true for me and, as I thought about my relationship to the curatorial premise of women of color working in abstraction, I found myself drawn to the artists in *Out of Easy Reach* whose practices too resonate with that experience—whose practices visualize the in-between, challenge binaries, and pointedly address the act of projection, of mapping onto another as a primary, albeit lacking, mode that humans use to navigate the world.

As the oldest work in the show, Howardena Pindell's groundbreaking video *Free, White and 21* (1980) most explicitly calls out the trauma of America's central racial binary, while disrupting the very idea of the body as a site for a single fixed identity. Performing two distinct and contradictory characters, Pindell plays herself and also an anonymous white woman, who dons cake makeup, a blond wig, and ridiculous cat-eye glasses. (It is worth noting here that *Free, White and 21* opens with a still title page—the names of the work and its author are typed in black letters on white, foreshadowing the symbolic use of stark text by other artists described later in this essay.) The bulk of the video consists of Pindell facing the camera head-on, calmly recounting chronological experiences of both blatant racism and microaggressions in her life. Throughout she is interrupted by the white character, who emphatically discredits Pindell's experiences and suggests Pindell is paranoid. The white woman uses white privilege as a navigational touchstone and viciously maps that experience onto Pindell.

But more important to this exploration of the in-between is the first anecdote Pindell relays before talking about herself—her mother's appalling experience with a white babysitter who mistook her dark skin for dirt and washed her with lye, leaving burn marks on her skin. This act of removal and erasure, of forced and failed transition from black to white is echoed at several points later in the film, in what might otherwise be construed as a series of abstract physical gestures. In one vignette, Pindell silently wraps her head in gauze; in another, she slowly pulls a thin layer of a white glue-like substance from her skin; later, the viewer returns to her wrapped face as she is removing the gauze. And then finally, in the guise of the white woman, she proceeds to cover her face in a stocking to deliver the final biting lines of the video. Through these gestures, Pindell performs a defiant abstracting of the self, of masking her blackness or alternatively her faux whiteness, moving back and forth between the two, which feels prescient and prefigures the contemporary identity politics that inform the work of many of the younger artists on view.

While Pindell challenges the fixity of the body as a racialized site, Bethany Collins is interested in the ways language performs racial binaries in the absence of the body. In her work *Southern Review, 1985 (Special Edition)* (2015), she literally blacks out with charcoal whole sections of both text and image of an issue of the titular magazine. At times complete pages are left virtually untouched, while at others the whole page is transformed into a full black form with little suggestion of what lies underneath. The result is an inscrutable geometry of squares and rectangles, whose hardened lines are variously softened by the familiar flow of text on the page and the fingerprints and smudges of the artist's hand. Like Pindell's stark black and white title page that introduces her more and less explicit explorations of race, the racial binary is made visible in Collins' work through black ink, charcoal, and the blank page, in the case of *Southern Review, 1985 (Special Edition)*, a creamier, warmer hue than traditional paper white. In an interview with Buzz Spector for *ART PAPERS*, in reference to the symbolism of black and white text in her work,

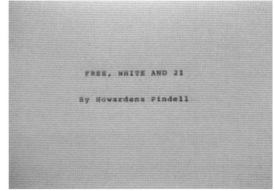

Still from Howardena Pindell's *Free, White and 21*, 1980. Color video with sound, 12 minutes 15 seconds.

1 adrienne maree brown, *Emergent Strategy: Shaping Change, Changing Worlds* (Chico, California: AK Press, 2017), 31.

Collins stated, "What consistently complicates and refutes that binary is the residue—the residue of language altered, blurred or partially erased presents a more complicated third way."[2] Collins originally negatively viewed the aforementioned smudges and fingerprints where she had handled the materials, throwing away the pages that ended up messy and ripped before realizing that the "sooty fingerprints all over the surface was the work." They were the body's insistence on the "third way," its refutation of categorization; in other words they were the space of the in-between.

Juliana Huxtable uses text, as well as her own body through photo portraits, as a way of exploring the limits of identity as a tool for ordering the world. Dispelling the gender binary, Huxtable has been vocal about her experiences as an intersex and trans woman. In works like *Untitled (For Stewart)* (2012), she pointedly pushes gender as a concept, projecting gender identities, fantasies, and struggles onto video-game characters and her adolescent peers. The memories may or may not be fictional, but in using the first person, Huxtable gives us, as viewers, permission to map them onto her. Looking at this through the lens of autobiography, through the body, it becomes easier to understand a later work like *Untitled (Casual Power)* (2015), which employs the same format, a crowded textual mash-up of sardonic techno-jargon and sincere Afrofuturist sensibility against a wavy, cosmically colored backdrop and which functions similarly as an exploration of the in-between. While in the former, we see the body as the mutable site, in the later work it is the more nebulous concept of place, with a space just beyond "HARLEM AND ALONG THE BRONX RIVER" that functions as a mythical land of female empowerment "WHERE BLACK UNICORNS RUN FREELY." Huxtable's vision extends beyond the in-between as part of any recognizable reality and instead pushes the site of utopia as an equally powerful potential in extremis. Binaries are rendered ridiculously irrelevant in a land of fantastical creatures where humanity itself is surpassed.

Ayanah Moor's *Good News* (2011) pulls the viewer back to more familiar geographies and instead figures the nebulous terrain of intimacy, suggesting that we assign abstract ideas like "culture" to place in the same way we map our desires onto the bodies of others. The immersive multi-print installation takes up the entirety of two walls. Each print, white letters on black background, begins with a location, then a quote about dating black women in that place. Moor covers important cultural centers: Oakland, Chicago, Los Angeles, New York, New Orleans, Atlanta, Nashville, and Philadelphia. Several tout the women in their city and the ease of dating there ("There are a lot of attractive, intelligent, open-minded black women in New York…."), while others lament the state of affairs ("The type of woman I would like to meet is not in Philadelphia…."). The statements, regardless of judgment, center personal preference and the universal abstraction of the ideal partner. Because Moor is a black woman and the commentary reads so casually, one assumes that the speakers are also black women, prompting fruitful consideration of how we judge bodies that we understand to be more similar than different to our own, which is accentuated by the repetitive black and white typographical treatment of each statement. But in the distinctions derived by place, we are also invited to imagine the variance of the speakers and the countless women they encounter in their lives, or that inhabit those places, pointing to a multiplicity of being and difference that makes the mapping of one self onto another ultimately such a painful and arduous task. We immediately recognize the fallacy, which strikes in the parallel in-between of humor and pathos. We've all been there, laughing and crying, at our lack of prospects for love and human connection in the world full of countless other bodies, unable to match available realities to our own desires and expectations of them.

The work of Caroline Kent abides most closely to our visual understanding of abstraction, but it similarly emphasizes the process of projection and translation. As a painter, Kent cites a dual influence of the Russian Constructivists and the experience of watching foreign-language films. In both, the presence of

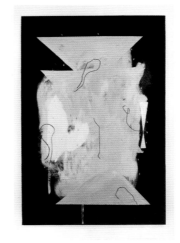

Caroline Kent, *First you look so strong, Then you fade away*, 2015. Acrylic on unstretched canvas, 108 x 72 inches (274.32 x 182.88 cm).

languages unknown to her creates a new relationship to text as symbol. With the former, in the absence of literal understanding, Kent found herself attaching new meanings to the interaction of images and Russian text. In the latter, she recounts becoming interested in the interstitial space that emerges from text (reading subtitles), image (watching a moving picture), and sound (listening to a foreign language). In her paintings, she fittingly seeks to develop her own language and test the limits of its translation, working from studies to create what she calls in an artist statement "a kind of alphabet in abstraction," encompassing form, color, and their interplay. This is evidenced in works like *First you look so strong, Then you fade away* and *Procession* (both 2015), which, despite their dissimilar approaches to negative space, find corollaries in their palette of icy greys and lavender tinges, their deep black backgrounds, and the hard edges of their irregular triangle and diamond shapes contrasted by sweeping gestural marks.

Returning to brown's quote, in thinking about the power of the in-between for her as a teacher, I'm struck by my own unconscious structuring of this essay as I made my own connections to, in, and between the works, searching for wholeness. I began with myself (the thing I know best) and moved to another person whose experience I found relatable, and it's no coincidence perhaps that when it came time to dive into the artwork itself, I ended on the most formally abstract, having started my analysis with the least, the most centered on the body, the site from which we navigate all things. Why then is abstraction such fruitful terrain for women artists of color? It's ultimately a question of visualizing the invisible work of relations, how we as humans learn to read situations based on available clues, learn to ascribe meaning by likeness, difference, and association, and how we share and communicate these learnings with others. In doing so, it provides the space for artists to explore the parameters of the body and offers a space to think not of the limitations of our lived realities but rather the potentials. For me, living in the in-between has made obvious the distance between expectation and reality—that expectation is an expression of ourselves, of our needs and desires to understand and make sense of the world, that nothing is quite what we think it is or should be, that it is all a little more complicated and connected than we initially perceive. The in-between denies the primacy of one reading, one experience, and instead forces us into a space of multiplicity and adaptability that is ultimately truer and more reflective of us all.

2 Buzz Spector, "Eight Questions for Bethany Collins," *ART PAPERS*, May/June 2016, http://www.artpapers.org/feature_articles/2016_0506-BethanyCollins.html.

LISA ALVARADO (B. 1982, SAN ANTONIO, TX)

CANDIDA ALVAREZ (B. 1955, BRONX, NY)

BARBARA CHASE-RIBOUD (B. 1939, PHILADELPHIA, PA)

BETHANY COLLINS (B. 1984, MONTGOMERY, AL)

ABIGAIL DEVILLE (B. 1982, BRONX, NY)

TORKWASE DYSON (B. 1973, CHICAGO, IL)

MAREN HASSINGER (B. 1947, LOS ANGELES, CA)

LESLIE HEWITT (B. 1977, SAINT ALBANS, NY)

SHEREE HOVSEPIAN (B. 1972, ISFAHAN, IRAN)

JULIANA HUXTABLE (B. 1987, BRYAN-COLLEGE STATION, TEXAS)

ARIEL JACKSON (B. 1991, NEW ORLEANS, LA)

STEFFANI JEMISON (B. 1981, BERKLEY, CA)

JENNIE C. JONES (B. 1968, CINCINNATI, OH)

CAROLINE KENT (B. 1975, STERLING, IL)

YVETTE MAYORGA (B. 1991, SILVIS, IL)

AYANAH MOOR (B. 1973, NORFOLK, VA)

HOWARDENA PINDELL (B. 1943, PHILADELPHIA, PA)

KELLIE ROMANY (B. 1985, BARATARIA, TRINIDAD AND TOBAGO)

XAVIERA SIMMONS (B. 1974, NEW YORK, NY)

SHINIQUE SMITH (B. 1971, BALTIMORE, MD)

EDRA SOTO (B. 1971, SAN JUAN, PUERTO RICO)

MARTINE SYMS (B. 1988, LOS ANGELES, CA)

ZIPPORAH CAMILLE THOMPSON (B. 1984, CHARLOTTE, NC)

BRENNA YOUNGBLOOD (B. 1979, RIVERSIDE, CA)

LISA ALVARADO

Artist and musician **Lisa Alvarado** fuses her visual and sonic practices in works that traverse the stage and the gallery. Alvarado began creating her *Traditional Object* series of tapestry-like paintings in 2010 as portable stage sets for the experimental music ensemble Natural Information Society. Although the works were originally intended as complements to musical performances, they also stand alone in a visual-art context, imbued with impressions of their musical origins. In Alvarado's words, "I always have been interested in the residue of how these things rub off on each other…What is the psychic residue, if anything, that is embedded within them, or within our memory? Does any sort of transformation happen?"[1] Her performances with Natural Information Society both echo and inform her *Traditional Object* series as the group layers and repeats disparate tones to create energetic soundscapes, resulting in a "sound that moves forward while simultaneously seeming to freeze time."[2]

Alvarado's large-scale paintings rely on repeating geometric motifs to create rhythmic patterns. Though her use of neon colors originally began as a function of the banners' use on stage, her references are multi-layered. The artist has cited Peruvian and Mexican textiles and their vivid tones as an influence, also evident in her titular reference to objects of tradition. Alvarado's employment of the loaded term invites the questioning of definitions and categories. How can an object be "traditional"? Traditional for whom, or to which culture? What would an untraditional object be? The notion of a traditional object is rooted in museum anthropological practices frequently contested within contemporary art.[3] Alvarado recounts a time during her studies when she realized encyclopedic museums often were acquiring Mexican-American artists for their folk art collections, while the contemporary art world seemed to completely ignore their work.[4] These titles may also be seen as a means of underscoring the intended uses of the works and their relationship to the artist's musical practice. Alvarado also employs spiritual concepts of talismans, mandalas, and ritual in her practice, connecting both her process and the viewing experience to a larger history of metaphysical exploration of aesthetics. By invoking these ethnographic forms of categorization, the artist acknowledges both the viewer and the systems through which art enters the public sphere. Her approach allows for a reflection on biases in American and Eurocentric museums that marginalize difference.

In *Traditional Object 15* (2014), the stepped, symmetrical pattern is placed off-center on a white painted canvas, with three edges of fringe. For the artist, a left-leaning composition represents "notions of the left-handed—the weaker, the other, the female—as explored by writers Robert Hertz and Gloria Anzaldua."[5] Alvarado's motifs begin with simple geometric forms resembling triangles and squares, which the artist outlines multiple times, softening their sharp edges. The new shapes are then tessellated, arranged in repeating permutations across the square background and maintaining the same dimensions and colors. On the upper left and bottom right corners of *Traditional Object 15*, elements of the pattern are abstracted further, appearing as if tears in the canvas are revealing woven fibers below. The trompe l'oeil effect helps the viewer imagine the textiles' utilitarian qualities, refracting and absorbing sound and experience.

In *Traditional Object 21* (2017), Alvarado works with a similar pattern but alters scale and color scheme in a vibrant expanse of vibration. Blue triangles oscillate diagonally across the field, alternating in a sharp, snake-like form with aqua and distorted orange trapeziums and lime accents, surrounded by a hot pink border. The large scale invites viewers to immerse themselves in the composition, suggesting the artist's musical performances, for which she plays harmonium, rhythmically submerging and washing over the viewer.

Alvarado's *Traditional Object* series unsettle the fixity of distinct categories of art. As portable, functioning sets they contribute to the atmosphere of her collaborative musical performances. Yet as paintings, they retain their implied relationship to sound. This duality alludes to the ethnographic histories of cultural artifacts that, while aesthetically pleasing, are even further illuminated through the context of their usage. As Alvarado makes works that have tradition in her own life, she invariably considers the distinction between artifact and artwork and the notion that aesthetics are irrevocably tied to real experience. [6]

MIA LOPEZ

1 Dana Kopel, "Vibrational Aesthetics: Lisa Alvarado," *Mousse Magazine*, May 2, 2017, http://moussemagazine.it/vibrational-aesthetics-lisa-alvarado/.
2 Marc Masters, "Joshua Abrams/Natural Information Society: Simultonality," *Pitchfork*, April 6, 2017, https://pitchfork.com/reviews/albums/22964-simultonality/.
3 See Kris Rutten, An van. Dienderen, and Ronald Soetaert, "Revisiting the ethnographic turn in contemporary art," *Critical Arts 27*, no. 5 (2013). Rutten, van. Dienderen, and Soetaert provide a thorough overview of this topic.
4 Lisa Alvarado, personal conversation, January 16, 2018.
5 Lisa Alvarado, personal conversation, January 11, 2018.
6 Alvarado cites Octavio Paz's 1977 essay "The Art of Mexico: Material and Meaning" as an important influence. Paz writes, "Like so many civilizations, Mesoamerica never conceived the concept of pure aesthetic experience. In other words, aesthetic pleasure, whether its source was popular and magical art or religious art, was not isolated but rather linked with other experiences. Beauty was not a separate value; sometimes it is conjoined with religious values and sometimes with usefulness. Art was not an end in itself but a bridge or talisman. A bridge- the work changes the reality that we see for another…The work of art is a medium, an agency for the transmission of forces and powers that are sacred, that are other. The function of art is to open for us the doors that lead to the other side of reality.

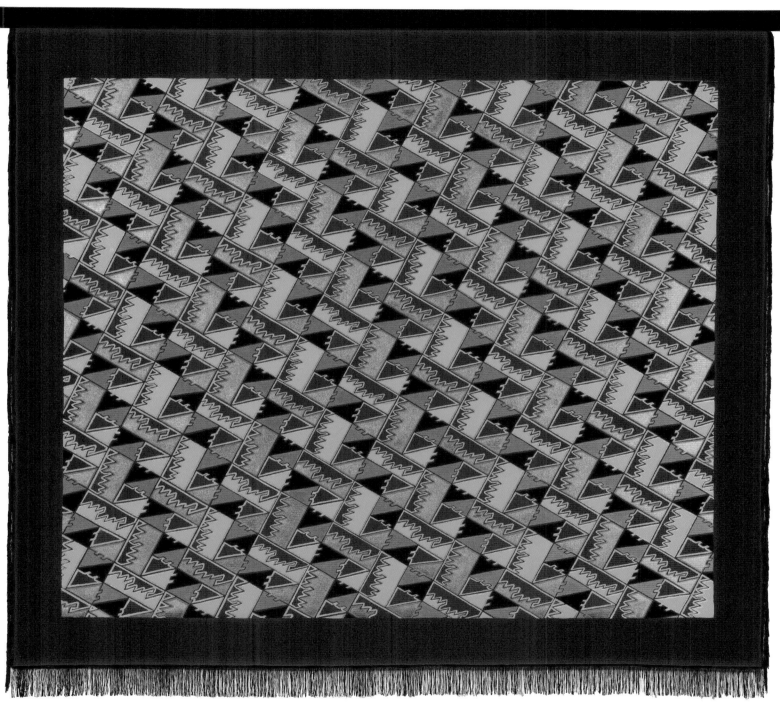

Lisa Alvarado, *Traditional Object 21*, 2017. Acrylic, fabric, and wood, 86 x 104 inches (218.4 x 264.2 cm).

CANDIDA ALVAREZ

The forms of **Candida Alvarez's** *chill* (2011) are defined through thick layers of paint in white and cool blues with small pops of yellow and red. Alvarez began this work by referencing a photograph of the Jackson Five, but the painting's subjects are hidden deep beneath the surface. Alvarez slowly draws the viewer closer with the texture of her raised lines and slick pools of paint. This large-scale, abstract work—seven feet tall and six feet wide—envelops the viewer and evokes a sense of calm, disguising the figures underneath with multiple applications of oil, acrylic, and enamel paint. Alvarez spent two months carefully sculpting thick lines across the canvas using a pastry sleeve made for icing cakes.

While at first her work may appear to have similarities to the great formalist abstract painters of the mid-20th century, cultural memory lies at the base of Alvarez's practice, and her process often begins with drawing images from the past, whether from the media or her own childhood in New York. As curator Allison Peters Quinn has written, "Popular culture, current events, and language provide the content for [Alvarez] to play off of or riff on in her paintings."[1] These references are visual and conceptual surprises, arising as the layers are peeled back to Alvarez's original points of inspiration. This layering is an essential part of her process of fragmenting representational forms to create work "where one thing builds on another thing," eventually taking the viewer to a world made up of bright, colorful abstraction.[2] However, *chill* is unique in its relatively subdued color palette and texture, giving a relaxed vibe in contrast to her more vivid canvases.

Alvarez has been painting for over 30 years, and her mixed-media practice has moved back and forth between the figurative and the abstract. Her process transcends the idea that abstraction is devoid of figure. According to the artist, in an interview with *Art21 Magazine*, her "work is made up of bodies, which have been mashed up and shredded into space."[3] She does not consider herself an abstract artist but builds assemblages of work from a variety of inspirations.[4] Her vibrant color combinations also caught the eye of avant-garde designer Rei Kawakubo and fostered a collaboration with the fashion house Comme des Garçons, which was presented at Paris Men's Fashion Week in January 2017. [5]

Alvarez notes that she is influenced by her community of artists—both from New York and her colleagues at the School of the Art Institute of Chicago—including figures like Elizabeth Murray, Howardena Pindell, and William T. Williams.[6] When I spoke with Alvarez, she also mentioned that her upbringing with Puerto Rican parents included church on Sundays, where she looked at the building's stained-glass windows, an early spark to her imagination and her devotion to color. Alvarez shares that she continues to be "seduced by color that lives in the world."[7] She asks the viewer to be seduced too, by the vibrancy of her canvases and of everyday life.

JENNIFER M. WILLIAMS

1 Allison Peters Quinn, *Candida Alvarez: mambomountain* (Chicago: Hyde Park Arts Center, 2012).
2 Candida Alvarez, personal conversation, May 23, 2017.
3 Caroline Picard, "Mashed Up and Shredded into Space: An interview with Candida Alvarez," *Art21 Magazine*, January 22, 2013, http://magazine.art21.org/2013/01/22/center-field-art-in-the-middle-mashed-up-and-shredded-into-space-an-interview-with-candida-alvarez/#.WdLHpBNSyfQ.
4 Alvarez, personal conversation.
5 Jason Foumberg, "To Pilsen Artist, Color Is a 'Flirtation with the Eyes,'" *Chicago*, April 26, 2017, http://www.chicagomag.com/Chicago-Magazine/May-2017/Candida-Alvarez/.
6 Alvarez, personal conversation. Alvarez is a professor of painting and drawing at the School of the Art Institute of Chicago.
7 Picard, "Mashed Up."

Candida Alvarez, *chill*, 2011. Oil, pencil, enamel and acrylic on canvas, 84 x 72 inches (213.36 x 182.88 cm).

BARBARA CHASE-RIBOUD

Barbara Chase-Riboud's *Little Gold Flag* (1985) stands at almost six feet tall and three feet wide, reflecting light off its shining surfaces while simultaneously absorbing it into corners and twists, entrancing the viewer. Intricate folds, ridges, and crevices of polished bronze create a complex heaviness atop the sculpture, as threads of gold silk, knotted and formed into rope, cascade down to the ground, looping before they return upward again, appearing to somehow support the weight atop. The two different materials meet fluidly, rather than in opposition—their differences, the disparity in weight and texture, creating a rhythmic balance. In this sculpture, and in each of Chase-Riboud's works, the artist presents, in her own words, "imaginary reincarnations"[1] of histories both personal and shared. *Little Gold Flag*'s title alludes to the many notions of flags, such as symbolizing pride of place, unity, deceit, and power, leaving the viewer with the question: *Who or what exactly does this* Little Gold Flag *represent?*

In 1956, Chase-Riboud completed her undergraduate studies at Temple University's Tyler School of Art, and, a year later, the artist received a John Hay Whitney Fellowship to study in Rome. She then returned to the United States for two years to complete her MFA at Yale University, before going back to Europe, making France and Italy her homes. An ocean away from the Pop Art and Minimalist movements happening in her home country at that time, Chase-Riboud's multidisciplinary approach to artmaking, which embraced the evidence of her own hand, remained at the forefront of her practice. In 1969, Chase-Riboud began creating some of her most well-known works, the *Malcolm X Steles*, a beautiful series of sculptures she developed using a new lost-wax technique in which she "could slash, fold, melt, chew, force and form these relatively light, highly pliable sheets [of wax] into deep cuts and undercut spaces that were impossible to achieve with a mold."[2] Once the wax molds were finalized and cast in bronze or aluminum at a foundry, she disguised the metal bases with flowing strands of silk and wool—hanging, knotted, braided, and looped—to give the sculptures the appearance of floating.[3] For this series, as with many of her artworks, she complicated her commitment to abstraction with a title referencing not only a person, but an entire movement that was demanding racial equality. As Carlos Basualdo states in the catalogue for the 2013 exhibition he organized of Chase-Riboud's work at the Philadelphia Museum of Art:

> [Steles] are conceived as an arrangement of floating signifiers, signs in the process of losing their attachment to a specific set of references. Steles are, indeed, veritable seals that both cancel a certain lived experience while opening a more social and literary field of remembrance—gateways that articulate a passage between the personal and the historical, the dimension of subjective perception and that of a common language.[4]

Although the process and outcome are different, Chase-Riboud's drawings share many exploratory threads with her sculptures. In her *24 Monument Drawings* (1996–97)—dedicated to a selection of artists, writers, historical figures, and places—abstract forms taking on the appearance of boulders and monoliths are connected, bound, and constrained through forces such as ropes and cords drawn around and among them, reminiscent of the *Malcolm X Steles*. Similar to the *Monument Drawings*, Chase-Riboud's fiction and poetry have also sought to highlight and imagine historical narratives from the vantage point of the present—from contemplating the revolt on the Amistad or the story of Sally Hemings' relationship with President Thomas Jefferson to imagining the life of Sarah Baartman, who was paraded around in freak shows as the "Hottentot Venus." And while she considers her writing practice separate from her visual-art practice, one can easily feel the space and weight of Chase-Riboud's written imagery, and see her symbolism echo in her drawings and sculptures. The title of her later *Tantra* series of sculptures (1984–2007) perhaps best suggests the strong binding force between all of her disciplines. In Sanskrit, "tan" translates to the verb "expand," and "tra" means "to liberate." As meditation and yoga teacher and author Sally Kempton describes, "Tantra describes itself as an expansion of the knowledge and practice that liberates us from suffering."[5] Whether through words in her poetry and novels, or through her drawings and sculptures, Chase-Riboud offers us space and materials for meditation, and the inspiration to expand upon, liberate from, and bring together our personal and shared histories and experiences.

EMILY WILKERSON

1 Ibid.
2 Ibid., 81.
3 Gwendolyn DuBois Shaw, "Malcolm X Rising: Barbara Chase-Riboud's Phenomenological Art," in *Barbara Chase-Riboud: The Malcolm X Steles*, 23. Classmate and friend Sheila Hicks recommended this technique and also taught Chase-Riboud a knotting technique, as described in Shaw's essay.
4 Carlos Basualdo, "Vertical Dreams," in Barbara Chase-Riboud: The Malcolm X Steles, 18.
5 Sally Kempton, *Awakening Shakti* (Louisville, Colorado: Sounds True, 2013), 29.

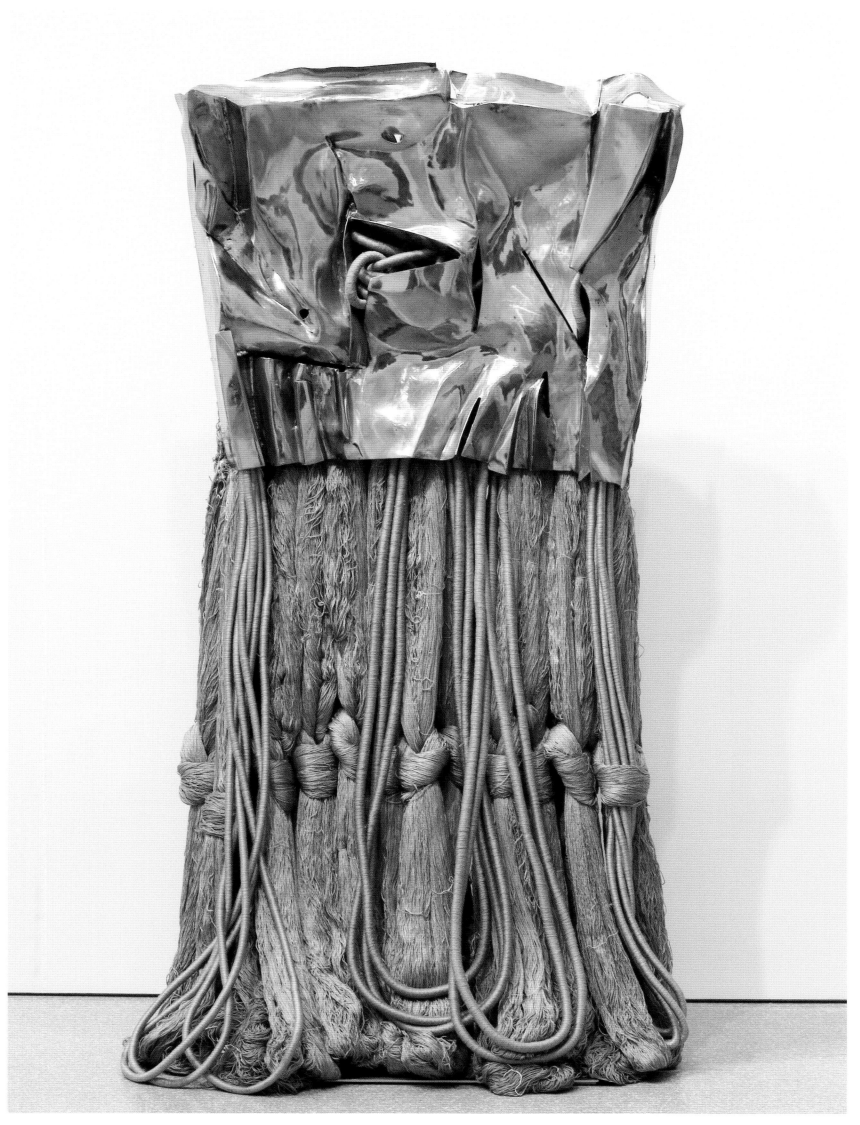

Barbara C ase-Riboud, *Little Gold Flag*, 1985. Polished bronze, silk, 78 x 26 x 15 inches (198.1 x 66 x 38.1 cm).

BETHANY COLLINS

Bethany Collins adeptly examines the written word and how visual representations of racial identity circulate. In a 2016 series of prints, which Collins titled after specific calendar dates (*May 3, 1963*, for example), the artist blind embossed white and black paper, faithfully reproducing newspaper pages yet rendering the text difficult to read. This gesture of negation is a commentary on the presentation of Civil Rights demonstrations in the editions of *The Birmingham News* printed on those dates. Collins uses the same technique in *A Pattern or a Practice* (2015), shifting her focus to the U.S. Department of Justice's 91-page report on the Ferguson Police Department, following the 2014 shooting of Michael Brown. The white, raised-text surfaces of the blind-embossed Somerset paper, printed to scale and installed in a grid, capture the overwhelming volume of figuratively and literally illegible information present in the report. In both instances the artist re-presents supposedly factual information while questioning its authority, drawing attention to language's inherent mutability. Collins favors a black and white color scheme throughout her practice, and takes interest in the different connotations colors may have, particularly pertaining to race. Works including *Colorblind Dictionary* (2015), in which she erased every color-related term in a found Webster's New World Dictionary, demonstrate her inquiry into language and semiotics.

Southern Review, 1985 (Special Edition) (2015) features 64 charcoal drawings on paper, arranged again in a grid. This is one work in a series of installations in which Collins uses *The Southern Review*, a literary magazine published by Louisiana State University in Baton Rouge, as her point of departure. The journal was founded in 1935 and is well respected for its presentation of fiction, nonfiction, and poetry. This special edition of *The Southern Review* includes a mea culpa from the editors for previous oversights about inclusivity and the underrepresentation of Black authors, while introducing this volume's address of those past biases. By centering the journal's title so prominently in her work, Collins calls into question the meaning of the term "Southern" and the many associations people may have with the American South, including racism and segregation. The artist dismantles a selection of pages from the publication and reorders them, stating "[the work] is my way of rewriting what…it mean[s] to be a Southern artist and the narrative that accompanies that."[1]

Although some of the original text remains visible, much is intentionally obscured with black markings, echoing government and surveillance practices of redacting sensitive and classified information. But the primary effect is to amalgamate the disparate sources—which include poetry by Amiri Baraka, an essay by Robert G. O'Meally, and an interview with both Josephine Baker and James Baldwin—with the rectangular charcoal forms, applied only to the bodies of the texts. This process leaves titles, footnotes, and other addenda visible, drawing attention to their structure and organization. Collins' stark geometric compositions and monochrome palette evoke Minimalist paintings and sculptures; however, *Southern Review* doesn't have the clean edges and precision that are the hallmarks of that movement. The work's charcoal smudges and visible fingerprints are reminders of Collins' presence and process and suggest the act of reading. In looking at *Southern Review*, the complexity of Collins' methodology is revealed: The artist deconstructs the formal aesthetics of language and literature while simultaneously addressing their content, offering poetic interpretations of processes such as erasing and editing. By collapsing form and content so fluidly, Collins instructs viewers and readers to do the same, both in the gallery and elsewhere, with words they have yet to encounter.

MIA LOPEZ

1 Buzz Spector, "Eight Questions for Bethany Collins," *ART PAPERS*, May/June 2016, http://www.artpapers.org/feature_articles/2016_0506-BethanyCollins.html.

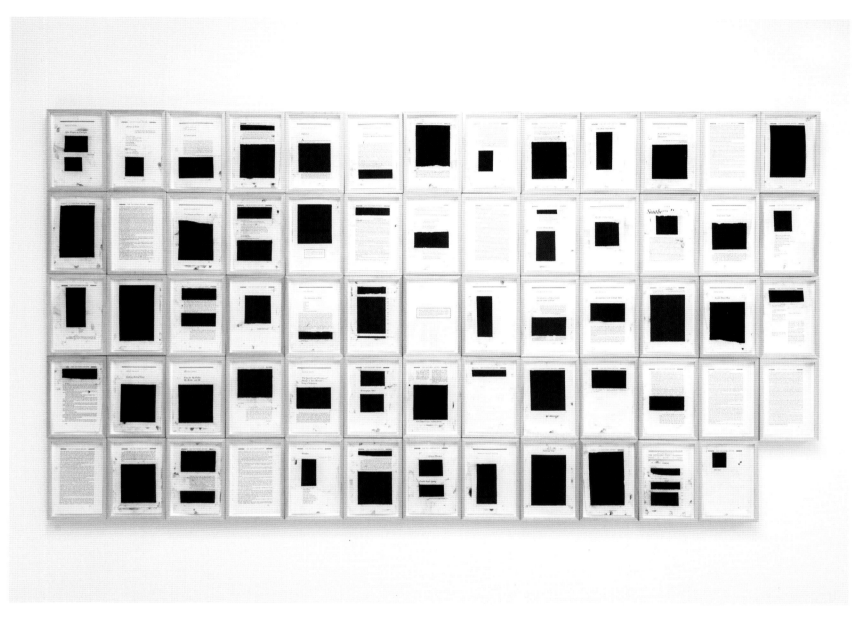

Bethany Collins, *Southern Review, 1985 (Special Edition)*, 2014-15. Charcoal on paper (64 pieces), 57 1/2 x 104 inches (146.05 x 264.16 cm) overall.

ABIGAIL DEVILLE

Abigail DeVille incorporates scavenged and archival materials into large installations that explore various scientific and social histories. Her works have included a wide array of cultural references, ranging from William Shakespeare's *A Midsummer Night's Dream* to the Great Migration. DeVille's work is unified through her analytic approach to sculpture, organizing unwieldly masses of repurposed material into site-specific forms.

Backlit by a television monitor, DeVille's *I am invisible, understand, simply because people refuse to see me* (2015) is composed of broken mirrors and archival photographs from the Vivian G. Harsh Research Collection of Afro-American History and Literature, housed at the Woodson Regional branch of the Chicago Public Library. (The collection is named after CPL's first Black librarian.) The faded images of the vintage portraits, school photos, and candid snapshots contrast sharply with the glow of the television, its screen displaying static, obscured by the other materials. Here, DeVille has ripped and cut copies of the photographs into forms resembling shards of glass, formally akin to the broken pieces of mirror strewn throughout the composition. The layering of the dissimilar materials in corresponding shapes creates a sense of depth and incongruity, rendering the work a portal to someplace else—another time or even another dimension. The void, particularly as it pertains to outer space, is a key concept for the artist, who states:

> Black holes are containers that are laden with forgotten information, the absence of light, power, knowledge and the harbinger of historical inaccuracies. I use celestial forms to think about our place in history, that links us to the beginning of time. Garbage contains the material history of the present and links to the past.[1]

By collapsing the notion of time in this work—pairing documentation from the 1930s to '60s with the contemporary radiance of a television monitor—the artist juxtaposes seemingly disparate cultural references to create new meanings, suggesting a unique interconnectivity across disciplines. The archival photos document the Black experience, with a specific focus on moments in Chicago's history, yet the people DeVille pictures are unnamed in the work and unknown to the viewer.[2] Similarly, the structure of the television is recognizable yet the screen does not transmit images and instead only displays static. Here DeVille ties in her research on space, as the fuzzy image commonly thought of as static noise on analogue televisions is partially due to residual energy, called the cosmic microwave background, from the Big Bang. By incorporating this energy into the sculpture, the artist emphasizes the enduring impact of the Big Bang on our universe, even after 13.7 billion years.[3] Even so, through the utilization of a broken television and old, faded photographs, DeVille questions the function and legacy of material culture, calling out the tension between the ephemeral and the archival.

The title is a quote from Ralph Ellison's *Invisible Man* (1952). In the novel, an unnamed African-American man struggles with feeling socially invisible amidst a racially segregated and oppressive society. The character's story of navigating mid-century American communities from an anonymous Southern town to Harlem, encountering Communists and Black nationalists along the way, is a testament to individualism in the face of racist stereotypes. DeVille alludes to another canonical work in the series' larger title, *Nobody Knows My Name*. Here she refers to the work of James Baldwin, who in 1951 published a collection of essays by the same name; like Ellison, Baldwin rebelled against reductive conceptions of identity in favor of more nuanced approaches.

By invoking both Ellison and Baldwin, DeVille establishes a context for her own analysis of identity politics. Through sculptural installation, the artist similarly ruminates on visibility in contemporary culture, connecting Black history from before the Civil Rights Movement to the present day. Though she embraces this historical trajectory, DeVille incorporates new media to push this concept further into the future, suggesting continued evolution and adaptation.

MIA LOPEZ

1 *Abigail DeVille: Nobody Knows My Name* (Chicago: Monique Meloche Gallery, 2015).
2 When researching, DeVille tracked the names of individuals and the collections in which their work could be found, but this information is not visually available to the viewer. For a 2015 installation at Monique Meloche Gallery in Chicago, DeVille used the Marjorie Joyner Stewart Papers, the Ebenezer Missionary Baptist Church Archives, and the Timuel D. Black Papers.
3 "6 Things you may not know about the afterglow of the big bang," Institute of Physics, accessed October 2, 2017, http://www.physics.org/featuredetail.asp?id=45.

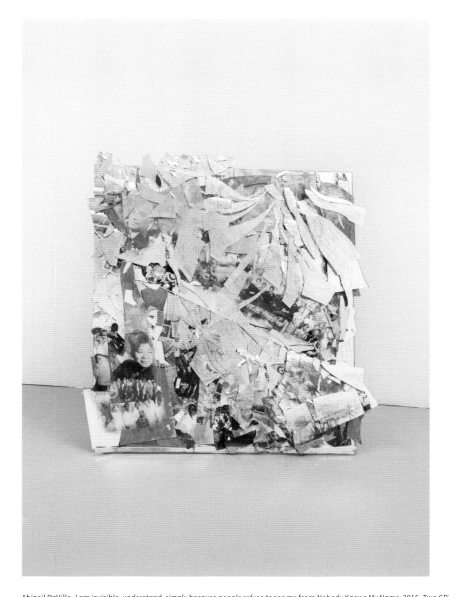 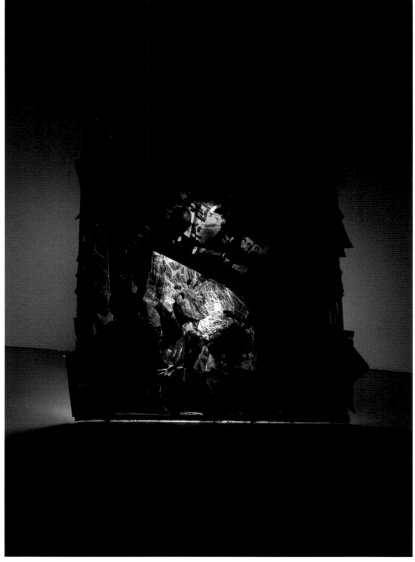

Abigail DeVille, *I am invisible, understand, simply because people refuse to see me* from *Nobody Knows My Name*, 2015. Two CRT TVs, mirrored glass, archival photographs from the Vivian G. Harsh Research Collection of Afro-American History and Literature, epoxy, mirror mastiff, 43 x 41 x 22 inches (109.22 x 104.14 x 55.88 cm).

TORKWASE DYSON

In built and natural environments, each object helps define our conditions of movement. The design of our physical world informs the methods in which motion emerges and spatial strategy is organized. For black people, moving through a given environment comes with questions of belonging and a self-determination of visibility and semi-autonomy. This means for the systemically disenfranchised, compositional movement (ways in which the body unifies, balances, and arranges itself to move through space) is a skill used in the service of self-emancipation within hostile geographies. Further, the brain deciphers, measures, categorizes, and understands both immediate and distant physical forms in relationship to the spatial structures defined by the conditions of power.

This relationship of interior and exterior—black mind/body geographic experiences—are inextricably tied to lands and waters riddled with architectural and infrastructural histories designed to isolate control over clean natural resources within white conservative and corporate hyper-capitalist systems. Disenfranchised people of color have inherited this geographic isolation and can name it environmental racism. In this moment of accelerated globalization due to technology, environmental racism is exacerbated by human-induced climate change, or what is being declared the Anthropocene. The legacy of environmental racism and the current traumas of global climate change make spatial planning—architectural and infrastructural representation and design—an urgent concern for me in contemporary abstract drawing.

Studio South Zero is a tiny mobile solar-powered art studio I built to cross the country, exploring geographic sites influenced by climate change and environmental injustice. It was the integration of abstract drawing, design, and technology that led me to make this portable studio. My efforts are focused on developing a distilled abstract drawing practice in the language of architectural and infrastructural representation that lends itself to participation in spatial development and more livable geographies. In drawing, I develop compositions, diagrams, marks, surfaces, and models toward these ends always with the movement of the human body in mind. Each drawing is a form of analysis, looking at the efficiencies in our current built and natural environments and the relationships people of color have to them. As we navigate built environments we did not design, that we've learned through our experiences, authority over one's mind/body in the labyrinth of forms, spaces, and objects is a question of race, composition, and materiality. From the concrete form of failed levees in New Orleans to the three 60-by-60-inch concrete squares underneath Eric Garner, we must be able to interrogate current infrastructure with new design solutions to advanced environmental conditions with our political and material futures in mind.

I ask myself how black people survive abstraction today as the scope, scale, and density of matter is changing all around us due to climate change? I begin to answer by looking at what I call *black compositional thought*. Abstract drawing can lend itself to the intellectual and psychological pursuit of pulling black compositional thought close. Really close, inside close. From the black-inside-black position, I stand in front of a surface with my mind in complete awareness of form as power. As I begin to convey shape, line, movement, weight, scale, proximity, and perspective, representations of subjects oscillate between scaled diagrammatic images and expressive drawings. In the act of making, I understand that it is the integrations of forms folded into the conditions of black spatial justice where I begin to develop compositions and designs that respond to materials. Here I open up the power of abstract representation while engaging with the emotional implications of design space itself. This is the critical tension in the development of solutions that extend beyond the surface area of the drawing and empathy and into measurable, efficacious applications. What emerges are ideas and capabilities in relationship to the varied material, geographic, and political conditions we inherit.

The abstraction I refer to is also the political abstraction used to enact hyper-capitalist and white conservative racist agendas upon black and brown geographies. For example, the history of policing and vagrancy laws, extraterritorial jurisdiction, and the exclusion of subjectivity in the discussion of the Anthropocene are all systems of political abstraction enacting modes of economic conservatism. These systems continue to traumatize as we are forced out and away from lands and waters that give us life and form our identity. This legacy of forced movement includes the intercontinental slave trade, environmental terrorism in the form of lynch mobs and the KKK, the burning of black towns and churches, coal mining, failing infrastructures due to disinvestment and underinvestment, the industrial and nuclear revolution, toxic waste contamination from industrial run-offs, rising sea levels, redistricting, curfew laws, the decrease in biodiversity, droughts, and the colonization of water for extraction industries. I begin to understand that surviving abstraction through abstraction is my formal project today.

TORKWASE DYSON

This excerpt is taken from a longer essay published on Pelican Bomb's Art Review on January 9, 2017.

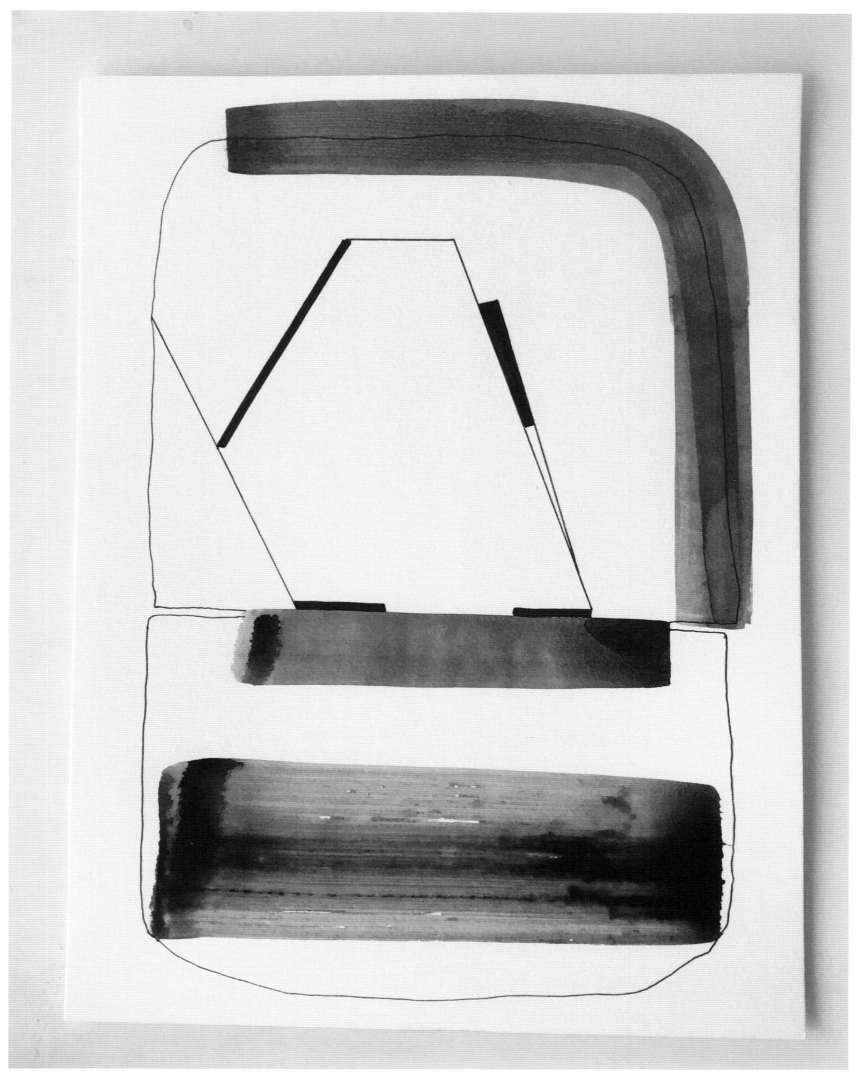

Torkwase Dyson, detail from *Untitled (Hypershape)*, 2017. 100 gouache and pen on paper drawings, 12 x 9 inches (30.5 x 22.3 cm) each.

MAREN HASSINGER

A motley array of pages twist and turn amongst themselves to conceal what appear to be black ink drawings on paper. Dark lines coil along the paper, although not a single piece within the bundle is fully exposed. *You gotta go for what you know. Make everybody see, in order to fight the powers that be...*[1] resonates from your temple to the back of your forehead as you read the title of **Maren Hassinger's** 2016 sculptural work *Fight the Power*.

If the only question you are asking yourself right now is *So what's on the page?*, you have missed the point. Admittedly, in my first encounter, I missed it too. For several days, my fixation on knowing rather than discovering (or imagining) for myself disoriented me. I had a burning desire to understand the artist's interpretation of what was happening with those tightly wound bundles of paper instead of seeking an explanation for myself. I wanted an answer. But something in my gut was telling me to pause and embrace the temporary lack of clarity. And so I kept wandering.

My eyes scanned *Fight the Power*, once again. And then again. Twists gave way to helixes. Helixes gave way to waves. What was once a clear path was blurred almost completely out of focus. It's easy to get lost here, just as one might find oneself lost at sea. I was thoroughly overwhelmed by a sense of total chaos. Each page of paper seems to be in its own way, wrestling with itself and, then, with one another, just to hold its own space in that field of beige and grey. But then the scene drastically changed. I noticed that, with the exception of a few outliers, the movements of these pages are actually in deep unison. It is the grouping of these individual life-breathing objects together that offers this work its undeniable power.

For over 40 years, Maren Hassinger has worked across disciplines in sculpture, installation, dance, and movement. Her career began with the latter two practices, which have quite literally shaped and contributed to her mastery of utilizing everyday materials in site-specific environments. Hassinger's graceful ability to set the stage for moving encounters with her sculptural and object-based work is one of the many reasons her work is frequently characterized as both transformative and commanding.

One can witness this in her seminal works, *Circle of Bushes* (1991), *Ancestor Walk* (1996), *Tall Grasses* (1989–90), and *Pink Trash* (1982), and in so many others, which highlight elements such as paper, branches, newspaper, wood, leaves, plastic bags, wire, and concrete. While her process employs altering gestures like the twisting, tying, wrapping, shredding, and grouping of objects, her methodology for doing so indicates a certain understanding and sense of respect for her materials. Whether it be with wood, metal, plastic, or detritus—her interventions with such materials do not change their forms so much that they are no longer recognizable. A piece of paper, when fully manipulated and transformed by Hassinger's hand, is still a piece of paper. This aspect of the artist's practice suggests a sense of reverence for the materials she works with, which, in turn, embeds a sense of integrity in the art objects themselves.

Coming back to *Fight the Power*—despite my initial inability to articulate what I was thinking, I did know how the sculpture made me feel. I thought of cooperation and resistance, materiality and the body, and that surreal feeling you get when those things are able to float and fly together at once. Diving a bit deeper, my own research for this piece brought me to revisit texts written by some of my favorite authors—Zora Neale Hurston, Octavia Butler, Audre Lorde, Suzanne Césaire, Angel Kyodo Williams, Robin D.G. Kelley, and Fred Moten—folks who totally revolutionized and uprooted my perceptions of freedom, self, collectivity, and tradition. Their contributions to Black thought urge us to reckon with the perils of existing in a ruptured society and equip us with the tools to fight the many powers that seek to destroy one's very being. While polarizing themes also come up in Hassinger's work—the natural and the human-made, for instance—the overarching message is about restoring balance. This in itself is a political act. Just as life requires both the inhale and exhale of our breath, so too must we labor, both individually and collectively, to cultivate order amongst chaos in an unjust and imbalanced society.

Fight the Power, then, becomes a mantra which propels us outward encouraging us to consider the spirit and the world around us. It commands us to do our part in dismantling and re-stabilizing equity in our current socio-economic and political state of absurdity. As an artist and a first-generation Nigerian-American woman living in Chicago in the 21st century, this call to arms feels imperative and timely. I continue to ask myself a set of questions, which I believe Hassinger is challenging us to contemplate today:

Who are the Power(s) that I/we must fight? And what Power(s) do I/we already possess to carry out the legacy of (Black feminist) radicality, imagination, and tradition?

ALEXANDRIA EREGBU

[1] Public Enemy's anthem "Fight the Power" was written for director Spike Lee's *Do the Right Thing* (1989), which examined the increasing racial tension in the Bed-Stuy neighborhood of Brooklyn.

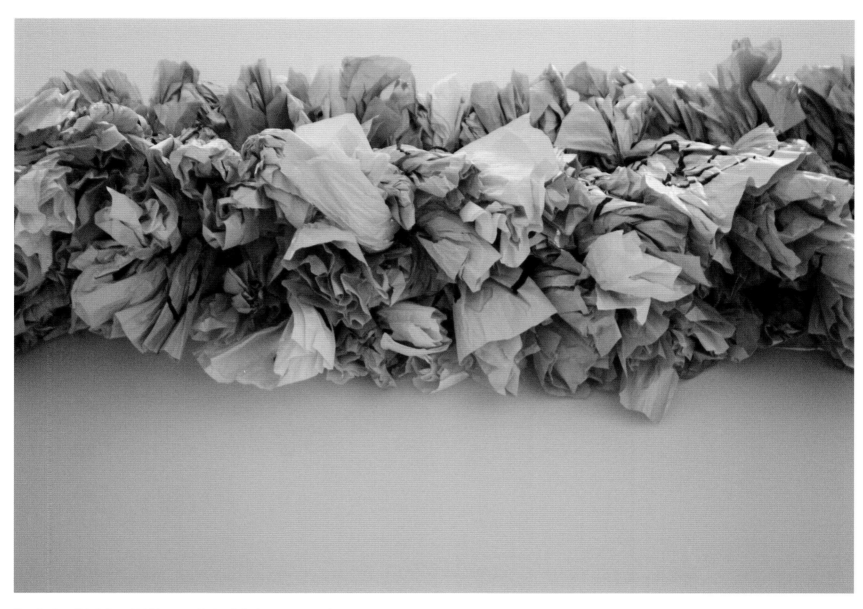

Maren Hassinger, *Fight the Power*, 2016. Ink on paper, 20 x 35 x 5 inches (50.8 x 88.9 x 12.7 cm).

LESLIE HEWITT

In **Leslie Hewitt's** *Riffs on Real Time (10 of 10)* (2008), the serene blues of the waterscape captured in a small photograph contrast with a wall of billowing smoke as fire engulfs an urban scene in what appears to be a page torn from a magazine. Like many of the various compositions constituting the photographic series *Riffs on Real Time*, begun by Hewitt in 2002, this image presents the viewer with a color-saturated and dramatically frontal perspective of layered images arranged neatly on the scuffed wooden floor of the artist's studio.

To produce her compositions in *Riffs*, Hewitt accrues source materials from her own archive or borrows them from friends and acquaintances. The juxtapositions of small snapshots, often featuring intimate moments of black life, placed upon torn or folded vintage issues of *Look, Ebony, National Geographic*, or *Life* conjure a visual landscape of the Civil Rights Movement and the Vietnam War era, but one in which national imaginaries constituted by press images are punctuated with quiet or passing moments of intimacy, leisure, or travel. In each arrangement, the indelible mark of the personal pressed against the discursive space of circulated, mass-produced imagery attests to the often unacknowledged conditioning of the public record of the past through the framing of one's private thoughts and desires. As such, the compositions of these photographs-within-photographs invite the viewer to become a decipherer of symbols. Depending on one's perspective on, or proximity to, the events of the 1960s, *Riffs* garners myriad meanings. For some, the fire-filled scene in *10 of 10* may register as a cropped *Life* magazine image depicting the racially-motivated Detroit rebellion of 1967, while for others, the burning building may remain more imprecise, a stand-in for universal struggles and hardships.[1]

Hewitt's attention to three-dimensional space—reflective of the artist's own training as a sculptor—situates *Riffs* both within and beyond traditional photographic discourse, imbuing the two-dimensional pictures resting on top of wood grain or the plush pile of brightly colored carpets with the aura of theater. The images, thus, function like props placed on a stage to advance a plot. Alternatively, the vertically aligned edges, and their carefully placed overlapping surfaces, gesture towards the methodical display of scientific specimens. As a result, the compositions hover somewhere between an engagement with lived encounters and the sanitized anatomy of history, a duality similarly proposed by Felix Gonzalez-Torres' untitled series wherein curators, collectors, and museums insert personal and institutional milestones into national or global timelines painted along the top edge of the wall. Both Gonzalez-Torres' and Hewitt's works point to the entangled construction of memory and politics, and how what remains noteworthy is often a haphazard refraction of personal and public investments.

Hewitt's configurations of images resolutely resist any fixed narrative by opting instead for a multiplicity of associative meanings, and yet, the pairing of water and fire discerned in *10 of 10* emerges as a reoccurring visual motif in the series as a whole. Hewitt's subtle, if not perhaps unconscious, reuse of juxtaposed fire, smoke, and water brings to mind the phrase of an African-American spiritual, made famous by James Baldwin's riff on it in his 1963 book *The Fire Next Time*. The lines read: "God gave Noah the rainbow sign/No more water, but the fire next time." Indeed, the spine of Baldwin's now iconic text, which comprises two essays about racism and inequality in the United States, is visible as one of the stacked books in Hewitt's *Untitled (Perception)* (2013), from her *Still Life* series, an inclusion that has been interpreted as a personal homage to her parents' active roles in the Civil Rights Movement.[2] Hewitt's display of *The Fire Next Time* attests to how this canonical text continues to serve as a point of departure for visual and literary artists today—recently the inspirational source for Ta-Nehisi Coates' *Between the World and Me* (2015) and the basis of the title of Jesmyn Ward's *The Fire This Time: A New Generation Speaks About Race* (2016)—showing how riffs happening in real time continue to shape a shared cultural consciousness about race relations in the U.S.

To be sure, a riff—most typically referring to jazz musicians' improvisational lifting and reuse of musical refrains—gains meaning through appropriation, repetition, and recirculation. Likewise, the riffs in Hewitt's work, whether visual or literary, deftly suggest that our understanding of our own encounters in the world—and with history—are not stable, but informed by complex entanglements of meaning that are constantly in flux. To this end, the arranged compositions of *Riffs on Real Time* far exceed the sum of their discrete internal parts. Just like a musical refrain whose impact broadens through repetition and contact, these stylized mini-archives of the past and present gain power from the unique personal associations that vibrate and seep outward from the momentary and unlikely touching of their edges.

FAYE GLEISSER

1 This image, which appeared as a press image in *Life* magazine in 1967, has been attributed to Declan Haun, a photographer who worked for both *Life* and *Newsweek*, and whose photographs appear in the permanent collection of art institutions including the Art Institute of Chicago.
2 Misa Jeffereis, "Leslie Hewitt," in *Ordinary Pictures*, ed. Eric Crosby (Minneapolis: Walker Art Center, 2016), 112.

Leslie Hewitt, *Riffs on Real Time (10 of 10)*, 2008. Traditional chromogenic print, 40 x 30 inches (101.6 x 76.2 cm).

SHEREE HOVSEPIAN

When Henry Fox Talbot invented the process of exposing light on paper nearly 200 years ago, he hadn't thought of a day when the digital would wipe out the need to spend time in the darkroom. In a time when many artists are changing their practices by turning to more instantaneous technological methods, **Sheree Hovsepian** uses a much slower photography-based studio practice to explore her intangible, inmost subjective world—a world that was shaped partially by her memories of youth.

The prevailing method of analogue image-making for Hovsepian is rooted in placing objects on light-sensitive board and exposing it, a reference to historical photograms, created by Talbot and others by leaving traces of plants on light-sensitive surfaces. For instance, *Reveries of a Solitary Walker* (2015), a mixed-media assemblage work, contains abstract photogram prints alongside delicate strings, brass nails, and wood. And these materials show, in the artist's words, "a correlation [between my current practice] with the hand-made and activities like knitting and crochet, which I used to do as a girl with my mother."[1]

In the piece *A Room of One's Own* (2015), Hovsepian suggests her own sense of geometry by incorporating strings and nails. Infusing photography with assemblage creates an optical illusion of an imagined space, a small room shaped by white thread, inattentive to the outside—while reminding the viewer of Virginia Woolf's influential essay. In *Autobiographical Time Travel* (2015), shapes resemble a childhood game of cat's cradle, another reminder of the fiber arts Hovsepian learned from her mother, revealing the artist's propensity to showcase femininity and independence by combining her signature abstract language with a framed photograph depicting a woman's exposed legs. (Fragmented photographs of women's bodies appear often in Hovsepian's works.)

Hovsepian was born in Isfahan, Iran, to a mother from Tabriz, a city known for its delicate weaving—a skill that has been inserted in the artist's work by her use of string, fabric, and macramé, and this process is especially present in her recent works, such as *Material Gestures* (2016), *Forced Arch* (2017), and *Visage* (2017). Her father is from Shiraz, a major wellspring of poetry and literature, and many of Hovsepian's works borrow their titles from historical texts, including *A Room of One's Own* and *Reveries of a Solitary Walker* (the latter named after an unfinished book by Jean-Jacques Rousseau). At the age of two, Hovsepian migrated to the United States with her family. This move didn't cease her learning about Persian culture as she recalls her mom reciting Hafez's poems. In the U.S., Hovsepian attained an academic education in the fine arts at the School of the Art Institute of Chicago, a major influence on her work as an artist.[2]

The illusory space that Hovsepian provides, which manipulates perspective in various dimensions, forces the viewer to imagine the artist's moments of decision-making in the creative process. In *Muse Music* (2015), she purposefully suggests the shape of swing music by juxtaposing string and pieces of brass in front of the curved black and white shapes of the background. Hovsepian, as a sensitive, intuitive maker, chooses specific materials, objects, and elements for her works. The viewer is able to feel the artist's presence by considering the sublime in the small, intimate moments of choosing to cut a piece of paper or to attach a golden string to a photogram.

In 2011, Hovsepian briefly experimented with color in her work. But after some trials, she resumed using only black and white, allowing form to play the main role in her works. Forms, free from intervention, manifest an edifying silence that asks the viewer to stop and be silent and contemplate the work. Hovsepian uses her constructions of images, materials, and abstract shapes to hint at her personal memories, and these compositions could bring forth the viewers' recollections too.

Hovsepian can be compared with Shirazeh Houshiary and Nairy Baghramian—who both also left Iran during childhood—as a triad of artists of the Iranian diaspora who each often use abstraction across various media to articulate their own ideas. Houshiary, a British-Iranian artist, uses her exploration of form to create the appearance of spiritual surfaces that transcend universal languages and cultures in her paintings and installations. Baghramian, who is German-Iranian, uses her conceptual multi-media sculptures to hint at political and historical concepts, whether stemming from her personal life or collective memory. And what Hovsepian perhaps does best is leave glorified traces of lucidity in her work, using abstraction as a language to point to the very inner state of the mind.

KIMIA MALEKI

1 Mark Westall, "Art Opening: Sheree Hovsepian | Konrad Wyrebek 'The Whole Other' an exploration of the undefined world," *FAD*, May 7, 2015, http://fadmagazine.com/2015/05/07/art-opening-sheree-hovsepian-konrad-wyrebek-the-whole-other-an-exploration-of-the-undefined-world/.
2 Sheree Hovsepian, personal conversation, August 30, 2017.

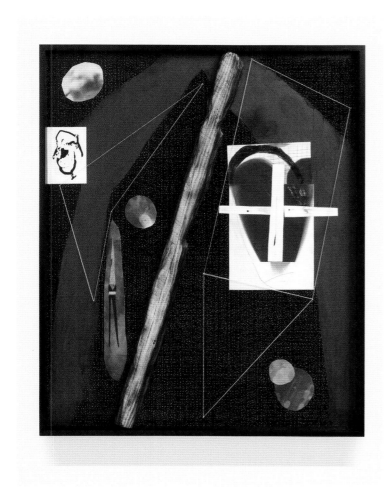

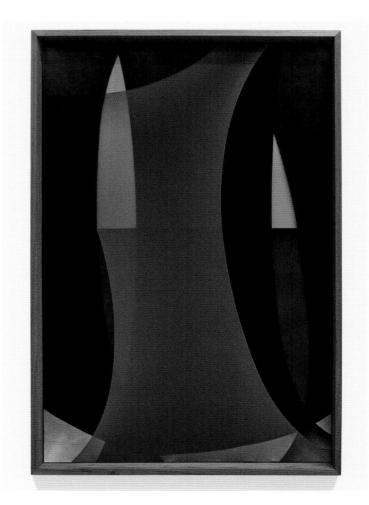

Sheree Hovsepian, *Reveries of a Solitary Walker*, 2015. Archival dye transfer, graphite, acrylic, silver gelatin prints, wood, ink drwaing on paper, brass nails, and string, 50 x 40 inches (127 x 101.6 cm).

Sheree Hovsepian, *Sway*, 2017. Unprocessed photographic paper, silver gelatin photogrpah, nylon, and artist made frame, 37 1/4 x 25 1/4 x 4 inches (94.6 x 64.1 x 10.2 cm).

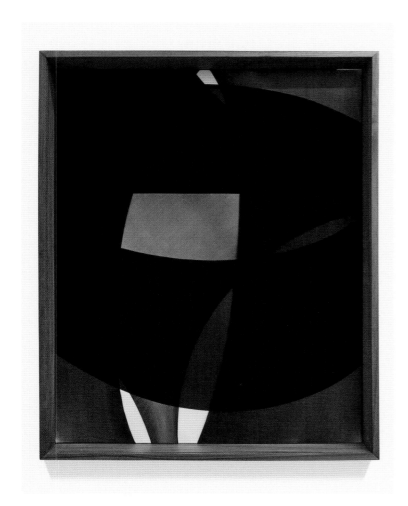

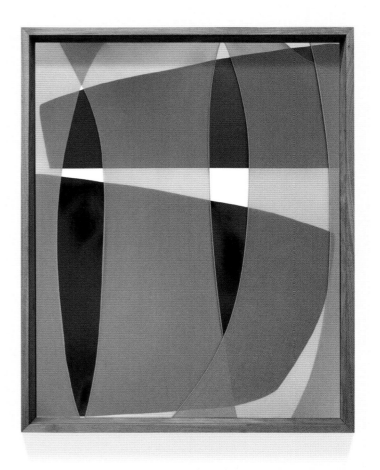

Sheree Hovsepian, *Lotus Position*, 2017. Silver gelatin photograms, nylon, and artist made frame, 31 1/4 x 25 1/4 x 5 inches (79.4 x 64.1 x 12.7 cm).

Sheree Hovsepian, *Form Body*, 2017. Silver gelatin photograms, nylon, and artist made frame, 31 1/4 x 25 1/4 x 5 inches (79.4 x 64.1 x 12.7 cm).

JULIANA HUXTABLE

In her multidisciplinary practice, which comprises photography, music, writing, and text-based prints, **Juliana Huxtable** examines the nature of subjectivity and signification. Her work across these varied mediums is unified by a characteristically futuristic, post-Internet aesthetic that enables a complex critique of race, gender, and sexuality at a distance from the traditional strictures of identity and representation.

Originally from Bryan-College Station, Texas, a conservative town within America's Bible Belt region, which the artist describes as unforgiving of racial and sexual difference,[1] Huxtable first came to prominence in New York as a DJ and creator of SHOCK VALUE, a weekly club event and self-described "nightlife gender project."[2] The strategies of remixing, juxtaposition, and appropriation central to DJing are also deployed in her visual art, wherein fantastical self-portraits or diaristic texts often reference or repurpose diverse sources, from fashion, science fiction, and personal memory to YouTube comment threads and right-wing political rhetoric.

In her large-scale, text-based works, Huxtable's poetry appears in uppercase type against celestial backdrops. *Untitled (For Stewart)* (2012) chronicles the childhood navigation of identity through video-game avatars: The piece invokes the genre's enforcement of damaging gender binaries, evident in both the "UN-INTERESTINGLY PHALLIC/KAMEHAMEHA SUPER-HEROES,"[3] as masculine archetypes or the "HYPER-PORNOGRAPHIC" bodies of femme avatars. Yet, it also touches on the possibility of queering virtual space through transgressive identification across this spectrum. "I DISCOVERED, USING MY VIRTUAL PUSSY TO STRADDLE THE BEEFY TRAPEZIUSES OF ANTHROPOMORPHIC CYBORG ATTACKERS," she writes, "THAT THE AWKWARD SHORTCOMINGS OF PUBESCENT LIFE COULD BE OVERCOME ONE PELVIC HEAD CRUSH AT A TIME." This perpetual overlaying and enmeshing of physical and virtual bodies reveals the artificial construction of gender in either realm, whereby identity is forged dialogically between self and society.

Though Huxtable often writes in the first person, her narrative style is not entirely autobiographical. She describes her writing process as "schizoanalytic," suggesting that the dominant voice within any given text encompasses multiple subjects.[4] Her cadence shifts seamlessly between points of view and grammatical tenses. Treating language as fluid and associative, Huxtable's texts reflect the many lenses through which we process, and are processed by, others and the world around us.

Untitled (Casual Power) (2015) complicates the notion of place; the narrative centers around a walk through Harlem and the Bronx presenting the urban landscape via spatial and temporal movement rather than from a fixed position.

Huxtable interweaves architectural, political, pop-cultural, economic, and ecological perspectives on the city. The city is described as un-mappable, "BEYOND THE BOUNDARIES OF GPS SOFTWARE UNABLE TO SENSE THE WALL OF ASHES (FROM BUILDINGS BURNT FOR INSURANCE MONEY) AND AMASSED SMOKE FROM CRACK PIPES." Ever-changing and anachronistic, her portrayal of the city favors intimate knowledge and personal association over public monuments and maps: New York manifests in "BANTU KNOTS AND BALD HEADS," in the echoes of Aaliyah and Octavia Butler, in the "NEAR TROPICAL HEAT OF A TOPOS UNDER GREENHOUSE EFFECT," and in a century of civic policies that have engendered and capitalized on racial disenfranchisement.

Huxtable's photographic works likewise disrupt categories of representation, merging self-portraiture and fantasy. She has long been fascinated by the Nuwaubian Nation, a religious cult which emerged in the 1960s and combined elements from Abrahamic and animistic belief systems, Black Power philosophy, popular science, and conspiracy theories. Her imagined, Nuwaubian persona was famously monumentalized in Frank Benson's 3D-printed nude portrait of the artist, *Juliana* (2015), which was exhibited in *Surround Audience*, the 2015 New Museum Triennial. Invoking the classical archetype of the *Sleeping Hermaphroditus*, her reclining figure is given a sleek, metallic finish in synthetic shades of indigo and green.

Huxtable positions this character alternately in post-Internet, planetary dreamscapes and more familiar, earthly environments. In *Nuwaub Chair* (2012), she poses nude atop a table in a snowy yard, surrounded by wooden fencing, bare trees and a stars-and-stripes-patterned fold-out chair. Huxtable appears mystical and other-worldly, her upper body a gradient of cosmic hues, her gaze fixed intensely on the viewer. Defying the destructive visual representations of black women's bodies throughout history, Huxtable appears transcendent, freed from the constraints of categorization and body politics.

ALLISON YOUNG

1 Hanna Hurr, "Juliana Huxtable," *Mask Magazine*, accessed August 2017, http://maskmagazine.com/the-street-issue/work/juliana-huxtable. In a 2014 interview with Mask Magazine, Huxtable recalls that, in her hometown, "there was a lot [of] gay-bashing, anti-abortion and racial tension."
2 Petra Collins, "Petra Collins selects Juliana Huxtable," *Dazed*, August 10, 2008, http://www.dazeddigital.com/artsandculture/article/20742/1/petra-collins-selects-juliana-huxtable. As Huxtable elaborates in the text, "Where was the nightlife run by women, cis, trans or otherwise? I just wanted a space where all of my friends could come together...where all of my trans friends could come without dealing with the anxiety that comes with many spaces."
3 Kamehameha is a common attack technique in the *Dragon Ball* franchise, in which a character thrusts an explosive beam of energy towards his target. In the context of Huxtable's critique, the attack mode serves as an analogy to the representation of male virility in the manga series.
4 Alex Fialho, "500 Words: Juliana Huxtable," *Artforum*, May 9, 2017, https://www.artforum.com/words/id=68284.

I ALWAYS PICKED THE GIRLS WHEN I PLAYED VIDEO GAMES. IF FOR NO OTHER REASON, THAN OUT OF SHEER SPITE AT THE EASE OF IDENTIFICATION THE BOYS AROUND ME HAD WITH THEIR UN-INTERESTINGLY PHALLIC/KAMEHAMEHA SUPER-HEROES... WITH THE ASSUMPTION THAT THERE WAS SOME SORT OF INHERENT OR TRAGIC FLAW IN PRINCESS PEACH'S MARIO KART 64 PERFORMANCE. CHUN-LI'S ABSURD CURVES AND THE CUNT'S MEOW SCREECHING FROM EVERY TURN OF HER HYPER-PORNOGRAPHIC BODY FUELED MY RAGE AGAINST BOYHOOD, ALBEIT THROUGH ARGUABLY THE MOST 'BOYISH' OF MEANS. I DISCOVERED, USING MY VIRTUAL PUSSY TO STRADDLE THE BEEFY TRAPEZIUSES OF ANTHROPOMORPHIC CYBORG ATTACKERS, THAT THE AWKWARD SHORTCOMINGS OF PUBESCENT LIFE COULD BE OVERCOME ONE PELVIC HEAD CRUSH AT A TIME. LIKE MOTOKO KUSANAGI, MY WOMANHOOD WAS ENTIRELY ARTIFICIAL, SAVE MY MIND AND THE TINGLING SENSATION IN MY SPINE PRESENT AT THE REVELATION OF A NEW LEVEL, ESPECIALLY ONE UNLOCKED AS A SECRET—EACH TIME MY ARTIFICIAL LUNGS LIFTED INTO THE AIR AS IF I WAS ÆON, BRAVELY DENYING VERTIGO OF ITS AFFECT AS I SPREAD MY AMAZONIAN LEGS AND TAKE IN THE RAPIDLY MOVING AIR THAT TRACES THE FANTASTICAL SKYSCRAPERS OF BREGNA. IMMERSED IN A WORLD OF POST-APOCALYPTIC INDUSTRIAL WAR-ZONES, I ASSUMED THE ETHICAL AND POLITICAL TASK OF FIGHTING OFF THE TENTACLE AGGRESSION OF HENTAI RAPE AND THE CHUCKLES OF MY PEERS SIMULTANEOUSLY. I WENT TO EVERY LAN PARTY IN HOPES THAT I COULD WITNESS THEM LOSE BATTLE AFTER BATTLE TO HYPERBOLIC DEPICTIONS OF THE SAME FIGURES THEY WOULD LATER JERK OFF TO; THE SAME FEAR-INSPIRING FEMME FATALE'S WHO THEY WOULD, AT SOME POINT ATTEMPT TO BATTLE IN THE REAL; THE SAME IMAGINARY CUNTS AND PHANTASTICAL PUSSIES THAT WOULD (AND STILL DO) TEMPT THEM TO TOUCH AND CONQUER THE VITAMIN-ENRICHED TUNA OF MY BODY.

Juliana Huxtable, *Untitled (For Stewart)*, 2012. Color inkjet print, 20 x 30 inches (50.8 x 76.2 cm).

ARIEL JACKSON

The Origin of the Blues (2015) is one in a series of short films created by New Orleans-born filmmaker and performance artist **Ariel Jackson**. The film begins with a voiceover by Jackson's alter ego, Confuserella — a recurring character in her practice at large—recounting how she "traveled from Panfrika to Plastica, to get [her] degree in finding the origin of the blues," so that she can go back to Panfrika, pump out the excess blues, and return things back to the way they were. Breaks in the narrative give way to other voices, introduced through archival video footage appropriated from police cameras, television interviews, and old films. This imagery unfolds over a rotating, animated pyramid (designed by collaborator Godfrey Hibbert), the walls of which fall and rise as the structure spins on the screen.

Through the abstraction of her body and her identity, Jackson builds a complex narrative around Confuserella's travels, and the character's plight to get to the origin of the blues is a concise metaphor for Jackson's experience of Hurricane Katrina. The artist's clever assemblage of found film footage articulates the inaccurate media portrayals of the communities most affected by the storm. Through the creation of an origin story, Jackson reconfigures history, creating a character that projects the artist into a cosmic imaginary space. Communicating through her performative alter ego allows Jackson to process and develop her sense of self both pre- and post-Katrina, within and outside of New Orleans. Jackson came of age during the storm, and the devastation and systematic racism that she experienced has been translated into the character of Confuserella.

Confuserella has been present in the artist's performance practice since 2011, emerging while Jackson was between her sophomore and junior years of undergraduate study at the Cooper Union for the Advancement of Science and Art. The persona was born out of the artist's shift from the South to the North, New Orleans to New York, combined with Jackson's desire yet inability to "speak with her whole body."[1] The artist notes that the development of Confuserella's character provides her with the "freedom to figure out [a] shifting identity."[2] This shift was propelled by challenges the artist faced when trying to communicate to her peers, who were distant from the situation, just how severely inequitable media coverage and rescue efforts were following Hurricane Katrina.

Law professor Bill Quigley's 2016 article in the *Huffington Post* provided concrete numbers regarding the inequities in income, affordable housing, social services, and demographics in post-Katrina New Orleans. According to Quigley, the stark differences in the city continue to become much more palpable as neighborhoods are redeveloped and resources are reallocated.[3] Through the adoption of an alter ego, Jackson obscures her body and likeness, which allows for the freedom to adopt a constantly shifting, adaptive perspective that is not constrained by the past or present—giving Jackson an opportunity to survey and process her experience while imagining a future that points to myriad possibilities.

ALLISON M. GLENN

A version of this essay was originally published on Pelican Bomb's Art Review on October 3, 2016.

1 Ariel Jackson, personal conversation, August 20, 2016.
2 Ibid.
3 Bill Quigley. "Katrina Pain Index 2016: Race And Class Gap Widening," *Huffington Post*, August 22, 2016, http://www.huffingtonpost.com/entry/katrina-pain-index-2016-race-and-class-gap-widening_us_57baf8e8e4b07d22cc390045.

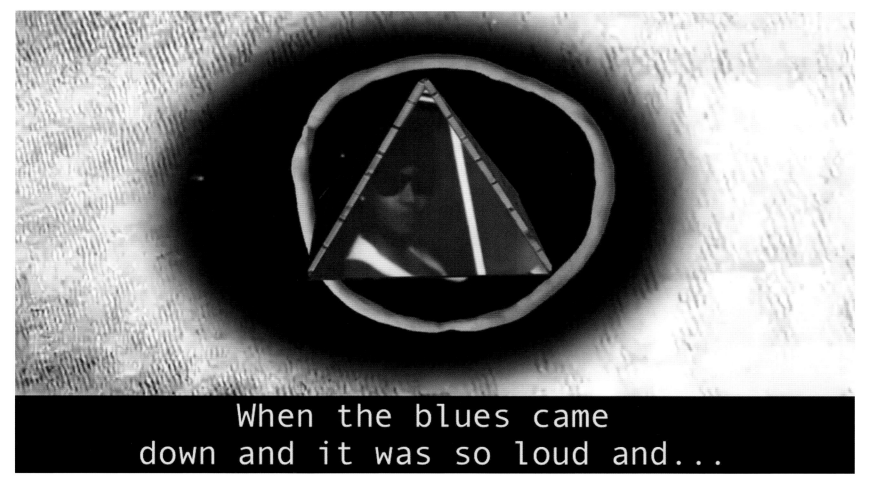

Ariel Jackson, still from *The Origin of the Blues*, 2015. High-definition video with sound (3D composting by Godfrey Hibbert), 4 minutes, 17 seconds.

STEFFANI JEMISON

From across the gallery space, **Steffani Jemison's** austere installation *Same Time* (2016) seems to float as if unmoored and weightless. Up close, one sees that the artist has drawn shapes on transparent rectangular sheets of polyester film; on a vertical sheet affixed to the wall, two flatly drawn, oblong black ovals appear, while directly below, on a white, low-to-the-ground plinth, another sheet of film rests, and a third elliptical loop and two more similarly abstract marks have been applied. Whether one sees in the dark acrylic shapes an art-historical reference to Salvador Dalí's Surrealist melting clocks, the inky swells of a wizened calligraphy tradition, or the ancient strokes of a hieroglyphic code, the gestural marks evoke the sense that what remains now is only a fragment of an elaborate whole. The space between the suspended forms and those lying scattered below give the imagination a place to ruminate on notions of whole and fragment, then and now, and legible and undecipherable.

It is no accident that these marks recall varying instances of handwritten letters or encoded sign systems. *Same Time*—also the title of the larger series to which this work belongs—encapsulates Jemison's characteristic method of examining language, abstraction, representation, and topography through photography-, film-, and sound-based installations to further interrogate conventions of knowledge production. In addition to her art practice, Jemison runs a publishing project, Future Plan and Program, which prints literary works by visual artists to support voices and ideas often eclipsed by hegemonic culture. Jemison aims to disrupt blind spots formed by the power structures that diminish marginalized subjects, instead providing a platform for their political imaginations to form and take flight.

In *Same Time*, Jemison plays with perspective and scale by producing inky shapes that multiply through their own mirrored reflections rippling across the surfaces of the film, or appearing as faint afterimages projected as shadows on the white gallery wall. In effect, she combines line, gesture, material, and architecture to create an installation that wavers and moves with the viewer, encouraging agile looking from the front and side, as well as from high and low and near and far. To see the work, then, is also to dance with it, to behold only an impression of its presence up-close or from across a room. In this way, the minimalist boldness of *Same Time* attests to how both the abstract forms of Modernist sculpture and the marks suggestive of an ancient, pre-literate moment share a common root: the longing for, and imagining of, a language with which to communicate or make sense of one's place in relation to others.[1] At the heart of this encounter with knowing and unknowing lies one of Jemison's utopian goals: "I'm interested in the political potential of non-narrative, of antiheroic ways of thinking about history, and of approaches that reject the march of 'progress' and development that has dominated modern storytelling," she explains.[2] Through lyrical gestures that seem

to both rest on the surface of *Same Time* and simultaneously recede into a prism of reflections, Jemison shows how traditionally fixed distinctions of both internal and external surfaces, as well as past and future forms of expression, can be collapsed. In an especially poetic instance of shape-making that defies common installation practices aligned with standard sight lines, the artist instead stipulates that the height and width of the installation be determined by carefully aligning the bottom corners of the two sheets.[3]

When *Same Time* appears as a larger series, as it did in her solo exhibition *Plant You Now, Dig You Later* at MASS MoCA, the resonance of the shapes shifts again—from an isolated event to a precarious but resilient archive of secretive markings. Inspired, for example, by Kevin Quashie's writings on quietude and the artist's research in the archive of James Hampton, an African-American "outsider" artist who left behind thousands of diary pages filled with his own private language, Jemison's labor can also be understood as an ambitious attempt to imagine an alternative language system that accrues its power through a tangible relation to the lived experiences of the bodies producing and consuming it. Populating the white-cube space of the gallery, the shapes become a landscape of tracks left behind, a mappable event of pasts colliding with the present. As the title of the series, *Same Time*, provocatively suggests, in Jemison's estimation, the category "time-based artwork" is misleading.[4] As she astutely points out, art, always insistent on the digestion of ideas, is never outside of, or without need of, the viewer's time.[5] What then, one must ask, fuels the desire for delineating how and which mediums are given to containing versus evading time? And how do these connotations of being in or outside of time condition how value is assigned, not just in art, but to bodies, languages, and events today?

1 Susan Cross, "Plant You Now, Dig You Later" in *Steffani Jemison: Plant You Now, Dig You Later* (North Adams, Massachusetts: MASS MoCA, 2017). Curator Susan Cross discusses pre-literacy and literacy in her essay for Jemison's solo exhibition at MASS MoCA: "Jemison explores two different poles—the impulse to wield language as a unifier, and to use it as a method of retreat."
2 Jess Wilcox, "Promise Machine: At MoMA, Steffani Jemison Explores Blackness and Utopian Thought," *Art in America*, June 24, 2015, http://www.artinamericamagazine.com/news-features/interviews/promise-machine-at-moma-steffani-jemison-explores-blackness-and-utopian-thought/.
3 Kemi Adeyemi, personal conversation, September 4, 2017. Kemi Adeyemi included Jemison's *Same Time* in the group exhibition *Unstable Objects* at The Alice in Seattle.
4 Wilcox, "Promise Machine."
5 Ibid.

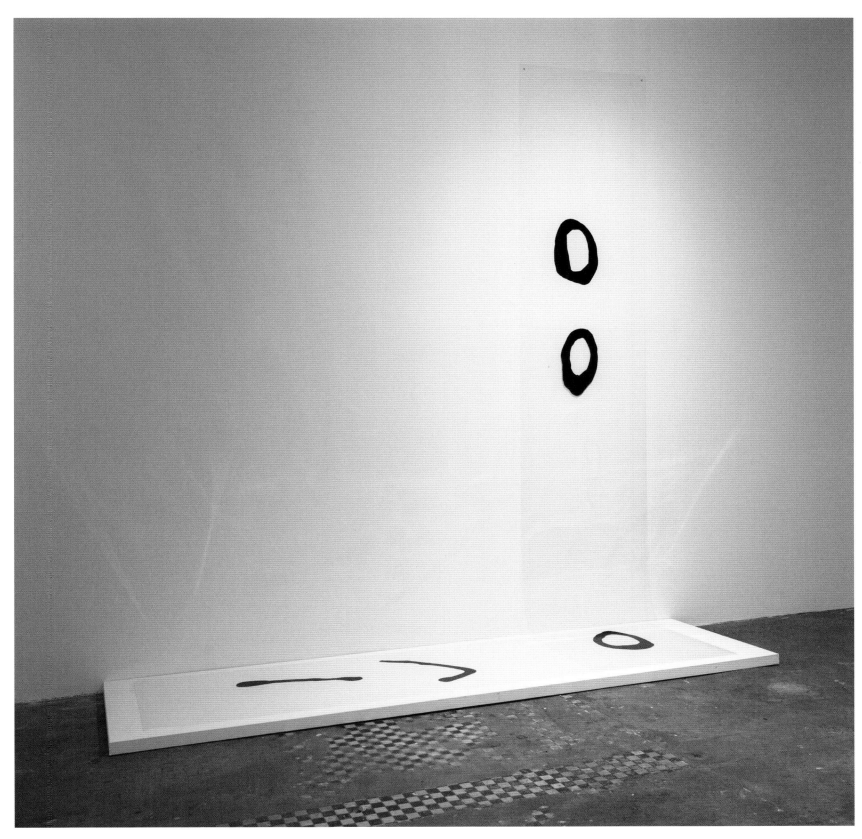

Steffani Jemison, *Same Time*, 2016. Acrylic on polyester film, 101 7/8 x 20 inches (256.7625 x 50.8 cm). | Steffani Jemison, *Same Time*, 2016. Acrylic on polyester film, 20 x 72 inches (50.8 x 182.88 cm).

The imperfect elegance of *Same Time* throws into high relief against a white ground the social politics of categorization. By defying easy recognition, and playing instead with shapes that evoke familiar bits and pieces of space, art, and speech, *Same Time* maintains its inscrutability while commanding time and attention through the occupation of space. And this is a tactic for resisting reductive figuration: At the moment one looks simultaneously at the surface and the wall behind, when one sees both the black shapes, and their reflections, and becomes aware that one is both looking at and through them, the radical value of opacity, of demanding multiple ways of looking and being seen, emerges.[6] It is in this seemingly impossible condition of viewership—at the same time looking at and through—that the labor of reading a surface and assigning it meaning is revealed as the complex battlefield upon which recognition of the self and others subsists. Language, Jemison's art reminds us, is visual, embodied, and dependent upon context, and, in *Same Time*, the resulting tension between abstraction, representation, and temporality points to potential alternatives for connectivity and being.

FAYE GLEISSER

6 Édouard Glissant, "Towards Opacity" in *The Poetics of Relation*, trans. Betsy Wing (Ann Arbor: University of Michigan Press, 1997). The complexity and dynamism that Jemison maintains within these shapes by suspending the act of looking at and looking through resonates with Édouard Glissant's theorization of opacity as the political horizon of personhood and the maintenance of ethical empathy.

JENNIE C. JONES

In history there are gaps, silences that belie assumptions of absence. **Jennie C. Jones**, in her work across painting, sculpture, collage, sound, and installation, critically engages the silences in the history of Modernism. Deeply rooted in jazz experimentation, Jones' work incorporates the language, materials, and idioms of music to interrogate the assumption of disjunction between mid-20th-century European-American and African-American avant-gardes. As the artist has said, "The underlying premise [of my work] is to advance an interest in exactly which modernist histories are seen and heard and which are omitted from the dominant narrative."[1]

Trained as a painter, Jones works across media to build on what she describes as the conceptual ideologies of jazz.[2] Modeled on the radical critiques and riffs within the genre, Jones' work also directly quotes the music itself. In her sound pieces, she samples Ella Fitzgerald, Billie Holiday, Charlie Parker, and more, isolating and repeating in Minimalist fashion individual notes or short phrases. Jones' reductivist strategy references not only Minimalism in music history but abstraction as a legacy in art history and in black history. This is the brilliance of Jones' project—she is able to wed abstraction in the visual arts to that in experimental music, while challenging histories that have denied the influences and cross overs between black and white avant-gardes.[3]

Focusing on modes of listening, Jones has also included musical notation into drawings, collages, and paintings; made sculptures from the devices through which music is heard, including Victrola horns, earbuds, and cables; and addressed the spatial aspects of sound by affixing diffusers and sound-absorbing panels to canvases. Jones' "acoustic paintings" are a growing body of work in which industrial sound-absorbing panels are connected to the surfaces and edges of painted canvases. *Gray Measure with Clipped Tone* (Inverses) (2016) is a two-part work that joins at a corner a long grey acoustic panel to a square canvas covered in thick white brushstrokes. In a restricted palette, redolent of her spare sound works, Jones has combined the sound-altering quality of the acoustic panel, representations of music notation, and a juxtaposition of hard-edge geometry and gestural painting. With simple means, Jones not only has made painting sculptural, but also has altered the sound of the space that surrounds the painting with the acoustic panel. The work highlights sound as something physical. Moreover, *Gray Measure* implicates one's body as Minimalist sculpture does, through confrontation and, in this case, acknowledgement of sound's own shape in the air.

The measure of the work's title is echoed in the notation of a musical bar line—a vertical line that marks a musical measure of standard time length—in the center of the acoustic panel. A second bar line marks the left edge of the canvas. Another series of Jones' acoustic paintings is based on the bar line and the double bar line, which denotes a stop, an ending. Not only are limits accounted for in time—the boundaries of a measure—but the clipped tone of the title refers to sound waveforms that are cut, or bounded, in distortion, whether digital or analogue. Clipped waveforms lose the top and bottom of the wave, creating a compressed sound, often described as "warm" or "dirty."[4] The upper and lower grey margins on Jones' right-side canvas might be said to visualize that clipping, translating physical properties of sound into painting. Incorporating painting, sculpture, the readymade, representation, abstraction, and language, *Gray Measure* is a genre-defying work that makes sound visual and physical, intertwining painting and music.

Jones' conceptual intervention across the aural and the optical recombines them into, to use the artist's words, "a territory not circumscribed by medium, race, or social milieu."[5] The gaps of history to which Jones points could be read as moments determined by stoppages, double bar lines, or limits, clipped tone. To bridge gaps and to shift the historical record, Jones uses form to harness history's exclusions, creating new pathways and making the fact of the past's silences evidently clear.

LORELEI STEWART

1 Jennie C. Jones, public talk at the Society for Contemporary Art at the Art Institute of Chicago, October 28, 2015.
2 Jennie C. Jones, "Artist Statement," Callaloo 37, No 4, Art 2014, 899.
3 See Fred Moten, *In the Break: The Aesthetics of Black Radical Tradition* (Minneapolis: University of Minnesota Press, 2003), 32. Moten has disputed the idea that the avant-garde "has been exclusively Euro American" and "necessarily not black." More specifically, in "Jennie C. Jones: 'Amazing Parallels'" from the *Compilation* catalogue, George Lewis writes, "John Coltrane was a major influence on LaMonte Young, Steve Reich, Terry Jennings, and Terry Riley, and a piece such as Coltrane's 1960 recording of *My Favorite Things* (particularly the McCoy Turner piano solo) is essentially a minimalist improvisation." Another scholar who explores Coltrane's impact on early Minimalist composers is Edward Strickland.
4 See Michael Campbell and James Brody, *Rock and Roll: An Introduction* (Belmont, CA: Thomson Shirmer, 2008), 80-81. As documented in *Rock and Roll: An Introduction*, the earliest blues guitarists to go electric used clipping to approximate the raw sound of blues singers. Chicagoans Buddy Guy and Elmore James notably led these 1950s innovations.
5 Jones, public talk at the Society for Contemporary Art. Of note in the context of *Out of Easy Reach*, just after this comment, Jones continued, "As a woman of color, it remains challenging to make non-narrative, non-figurative artwork, and I've struggled for years to break apart and shift the discourse, to expand notions and push against expectations."

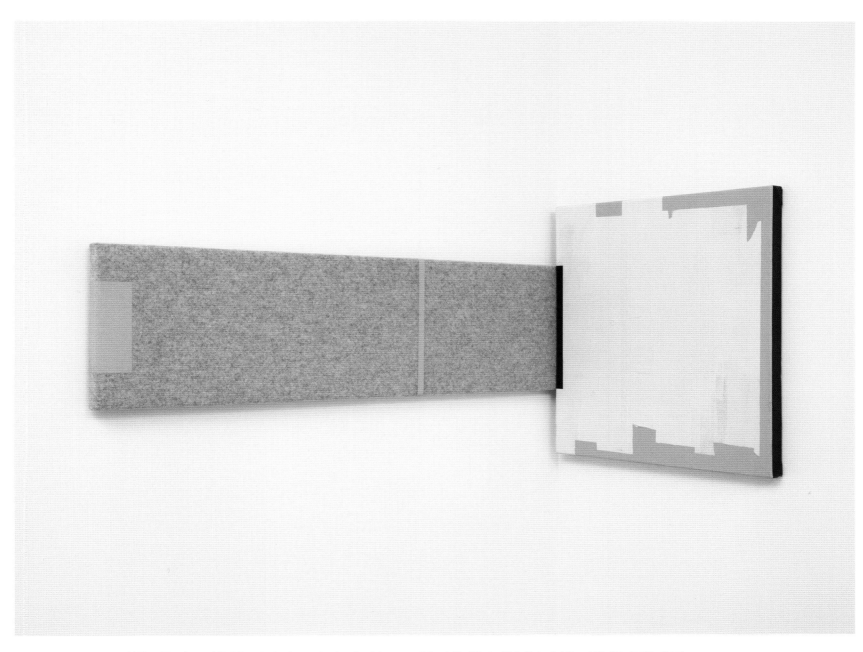

Je¯nie C. Jones, *Gray measure with Clipped Tone (Inverses)*, 2016. Acoustic absorber panel and acrylic paint on canvas, left part: 12 x 36 inches (30.5 x 91.4 cm), right part: 24 x 24 inches (61 x 61 cm).

CAROLINE KENT

Caroline Kent's exploration of language and semiotics has evolved through the production of abstract paintings on paper. Her compositions use geometry, color, and pattern as a method of communication, suggesting a visual manifestation of linguistic concepts of rhythm, tone, and cadence. Kent positions abstraction as a language and translates cultural references and her personal experiences through her painting, inviting the viewer to explore a new visual syntax.

Kent primarily creates large-scale compositions, beginning with a matte black background upon which a visual glossary of gestures, shapes, juxtapositions, and patterns is assembled. The decision to consistently begin with solid black is an effort to challenge the formal notion of the white background as a natural beginning or a neutral starting point. In Kent's paintings, the black space is not a flat shape, but instead an opening to a different kind of space, amplifying the artist's use of color to create depth and dimension. Though Kent is quick to dismiss notions of specific formal references in her paintings, she acknowledges that images may become ingrained in her mind and reemerge as impressions, transformed into new shapes with mere traces of their original forms. "[There are] things I've seen in the world that carry a profound presence that I think I end up trying to bring into the work. They don't look like the things anymore but they bring that same presence."[1]

For example, with *Procession* (2015), Kent's titular reference evidences her interest in movement and time. At the top of the composition, a repeating pattern of small yellow diamonds links two mysterious forms. Like most of the shapes Kent uses, these are ambiguous, yet familiar, evading specific recognition. While these shapes may subtly call to mind heads of hair, they are detached from any face or corporeal entity. In the center of the painting, a lavender cloud partially obscures an arch lined in white, resembling the entrance to a tunnel. The work then becomes an entry point for the viewer to consider travel, perhaps entering a passage into an alternative universe, a portal to another space and time. Science fiction is an important reference for Kent, who sees abstraction as a means to explore the possibilities of other worlds, and her paintings suggest the potential for elements from other realms to coexist with our earthly reality.[2]

In *First you look so strong, Then you fade away* (2015), Kent borrows lyrics from "Vapour Trail," a 1990 song by the British shoegaze band Ride. The artist describes the work as romantic, alluding to the soft, dreamy melody of the song with

obscured, semi-opaque triangles in a cool-toned haze. The clean geometric lines of the faded triangle dissolving into billowing fog echo the title phrase and evidence a tension between sharp and soft, which Kent often plays with. The pale, nearly pastel tones are sporadically punctuated with turquoise hatch marks and strands of blue bead-like dots.

Kent's impetus for creating abstract painting began upon close consideration of foreign-language films. She recalls a period early in her practice when she was compulsively watching movies in different languages and was fascinated by the dissonance between her visual and auditory experiences. The artist was intrigued by the idea of a "spoken language that certain people are privy too but others are not" and wondered how this might relate to the experience of simultaneously hearing a foreign language, watching a moving image, and reading textual subtitles.[3] In addition to film, Russian Constructivist collages became a major influence on her work at that time. Not being able to read Russian, Kent understood the Cyrillic alphabet on a purely formal level, rather than as semiotic indicators of language. She found herself relying on contextual clues and images to extrapolate meaning. Just as the Constructivists interrogated the separation of form and meaning, Kent's paintings explore the relationship between vocabulary and abstraction. Initially inspired by the disconnect between what is seen and what is understood, the artist's works hover in between, embracing ambiguity and illegibility in painting and beyond.

MIA LOPEZ

1 Caroline Kent, personal conversation, June 27, 2017.
2 Ibid.
3 Ibid.

Caroline Kent, *Procession*, 2015. Acrylic on unstretched canvas, 108 x 72 inches (182.88 x 274.32 cm).

YVETTE MAYORGA

At first impression, **Yvette Mayorga's** confectionary sculptures give an impression of saccharine sweetness and colorful celebration. Yet when examined closely, the fragrance of sugary icing gives way to abject forms peculiarly distorting everyday objects such as toys, photographs, and decorations. Mayorga imbues traditionally joyful items with ambivalent meanings, creating a subterfuge to deliver a sharp critique of border politics and the relationship between the United States and Mexico. Referencing her own family history, her father's immigration story, and universal notions of utopia, she creates works that provide vehicles for dialogue around trauma, memory, home, and nationhood.

In the installation *Monuments* (2015), short, pillar-like sculptures combine frosting, foam, plaster, party decorations, toy soldiers, guns, hair, balloons, wood, fabric, handcuffs, and a photograph of the late singer Selena Quintanilla-Pérez. Mayorga combines these items to explore her own identity as a Mexican-American and to allude to the immigrant fantasy of the American Dream. Mayorga's exploration of the immigrant experience and her critiques of the false utopia of American life are evident in her references to abundance and waste. Sporadically integrated textual elements written in icing underscore her point of view, stating matter-of-factly "US funds drug war" and "La vida es dolorosa" ["Life is painful"].

The sculptures in *Monuments* are saturated with bright tones of purple, pink, yellow, and orange. They each consist of a foundation of plaster bricks, skewered by rods for support and then adorned in frosting and found objects. Nostalgia is important to Mayorga, as she recalls seeing family photos from the 1970s of birthday parties in Chicago and Mexico.[1] Unable to experience celebrations and gatherings that happened before she was born, creating the works has become a way for the artist to connect with her family's history by translating and relating to her feelings about these past celebrations. Mayorga avoids duplicating specific details, and the chaotic drips of icing and clusters of found objects on the sculptures' surfaces reveal the artist's hand. She uses cake-decorating tools to adorn her collections of readymade objects, transforming refuse and scraps into inedible yet painstakingly embellished desserts. Aesthetically, Mayorga makes use of a baroque approach to materials, piling volumes of icing and objects upon each other to build forms that draw attention to their own precarious structures and gluttonous excess.

Desire and deception are central to Mayorga's works, and, for her, emotion is closely linked to the politics of immigration. Just as her sculptures take on the appearance of sweet confections, but are actually inedible, the artist posits that the image of the United States as a place of prosperity and happiness is also superficial. Mayorga also sees her sculptures as monuments or shrines to transnational figures alive and dead—including Selena; the artist's mother and sister; and anonymous immigrants—celebrating their perseverance. She creates the sculptures at human height to further reinforce their connection to the body. Though conventional monuments typically use figurative sculptures to honor historical figures like generals and politicians, Mayorga's use of the term in her titling demands close consideration of whom these towers of slathered frosting and inexpensive tchotchkes represent. Though Mayorga's subjects are not always explicitly or fully named, their presence is nevertheless felt.

MIA LOPEZ

1 "#StudioLife Yvette Mayorga," *Rainbowed*, May 1, 2017, https://www.rainbowed.us/art/studiolife-yvette-mayorga/.

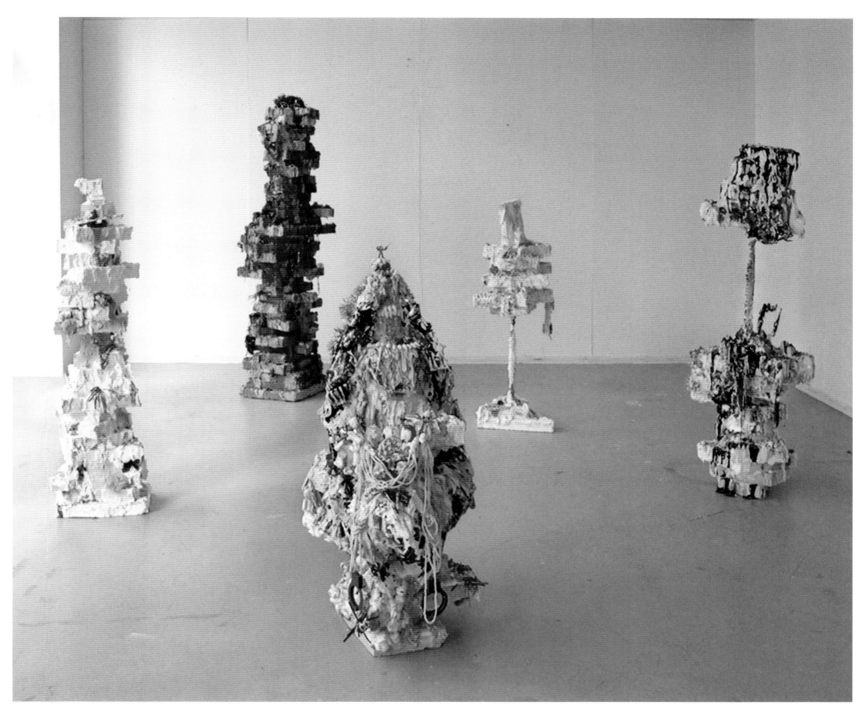

Yvette Mayorga, installation view. Left to right: *Monument 4*, 2015. Frosting, foam, plaster, party decorations, toy soldiers, guns, hair, balloons, wood, fabric, acrylic, and handcuffs, 48 x 12 x 12 inches (121.9 x 30.5 x 30.5 cm). | *Monument 5*, 2015. Frosting, foam, plaster, party decorations, toy soldiers, Selena's picture, guns, hair, balloons, wood, fabric, acrylic, and handcuffs, 72 x 30 x 30 inches (182.9 x 76.2 x 76.2 cm). | *Monument 2*, 2015. Frosting, foam, plaster, party decorations, toy soldiers, Selena's picture, guns, hair, balloons, wood, fabric, acrylic, and handcuffs, 30 x 24 x 24 inches (76.2 x 61 x 61cm). | *Monument 3*, 2015. Frosting, foam, plaster, party decorations, toy soldiers, guns, hair, balloons, wood, fabric, acrylic, and handcuffs, 24 x 6 x 24 inches (61 x 15.24 x 61cm). | *Monument 1, 2015*. Frosting, foam, plaster, party decorations, toy soldiers, guns, hair, balloons, wood, fabric, acrylic, and handcuffs, 48 x 12 x 12 inches (121.9 x 30.5 x 30.5 cm).

AYANAH MOOR

Ayanah Moor's conceptual practice is informed by both language and the politics of desire, and much of her work addresses issues related to sexual identity, gender, and race. Through the appropriation of a wide range of already existing cultural artifacts and texts—including articles and images from magazines, songs by Shabazz Palaces and Sir Mix-a-Lot, and a photograph of Supreme Court Justice Sonia Sotomayor—the artist creates space for alternative histories, aiming to decentralize common social structures and subject positions that tend to privilege white heteronormativity above all. For Moor, these revised narratives are rooted in the ways images, texts, and identities are interconnected in the public sphere: "My work explores the way popular culture is an articulation of our desires, our fears, our fantasies. It can both reflect and impact the things we want, which is a fascinating cycle."[1]

In *Good News* (2011), Moor appropriates women's responses from a 1980 article in Ebony titled "What They Say About the Men in Their Towns." Screen-printed in all uppercase lettering on newsprint and installed in a grid—which the artist reconfigures to fit different gallery spaces—Moor's artwork gives a formal nod to the Conceptualists who came before her. Aesthetically, one thinks back to the gridded works of Hanne Darboven, who often transcribed the writings of others and collected and displayed repeated images from popular culture in her work. Darboven's epic installation *Kulturgeschichte 1880–1983 [Cultural History 1880–1983]* (1980–83) includes multiple repeated found images and texts framed and hung in grids that dominate the gallery space. Combining magazine covers and postcards with documentation of her own work, Darboven intermixes details from her personal life with society as a whole.[2] Similarly, in Moor's installation, the repetitive nature of the grid and the texts—a collection of prints displays women's responses from eight cities—creates an all-encompassing architectural space, one that has a demanding physical presence, in contrast to the personal nature of the subject matter.

In *Good News*, Moor replaces the male pronouns in the women's original statements with female ones, shifting the statements to represent instances of queer black female desire. Reporting from major cities such as Philadelphia, Oakland, Chicago, and Atlanta, the original Ebony article included a headshot of the women who made the statements, but in Moor's work, the text stands alone and acts as an image—allowing viewers to imagine both who is speaking and who is being spoken about. There are both positive and negative statements, but texts that particularly stand out portray the individuals as non-wife material, women who are not looking for monogamy, or confirmed bachelorettes. One reads, "There's no wife material in New Orleans. Most of the women want more than one woman. They play the field because they have their choice of women. I wouldn't recommend New Orleans to single women looking for a woman."

Each of these statements is complicated by this gender swap, as their original intentions are what might be considered stereotypical of men—such as continuing to play the field and not wanting to settle down. However, with the goal of equality between the sexes in mind, it is particularly poignant for the viewer to read these statements and think of women. *Good News* suggests an alternative discourse that is less fixed to traditional gender roles and heteronormative understandings of relationships. Moor's work acts as an entranceway for a larger conversation regarding the influence of popular culture on how we understand identity, gender, and race.

RACHEL ADAMS

1 "Ayanah Moor: The Window of Popular Culture," Carnegie Mellon University, accessed June 25, 2017, http://www.cmu.edu/homepage/creativity/2009/fall/ayanah-moor.shtml.
2 "Hanne Darboven: *Kulturgeschichte 1880–1983*," Dia Art Foundation, accessed October 2, 2017, https://www.diaart.org/program/exhibitions-projects/hanne-darboven-kulturgeschichte-18801983-exhibition.

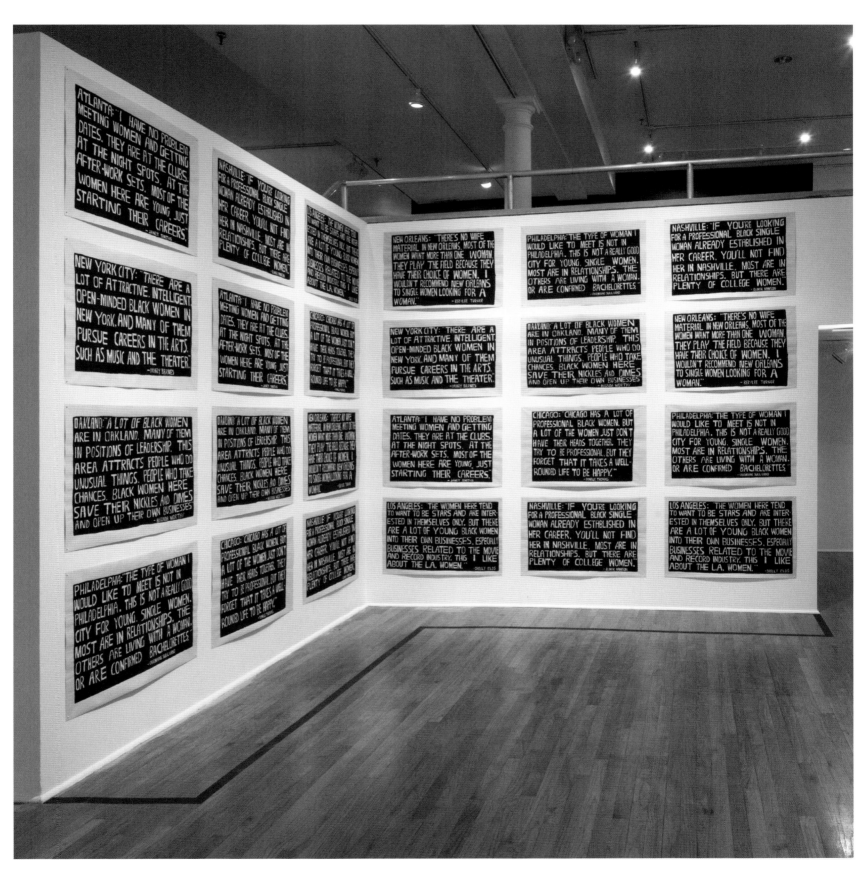

Ayanah Moor, *Good News*, 2011. Silkscreen on paper (24 pieces), 24 x 36 inches (60.96 x 91.44 cm) each.

HOWARDENA PINDELL

In **Howardena Pindell's** *Free, White and 21* (1980), the artist sits in front of a backdrop that changes between blue, orange, and green. She recounts several stories of racism she has experienced, interspersed with scenes of her in early-'60s drag where she acts out the role of a white aggressor. The relevance of this costume is connected to the history of the term "free, white, and 21," a catchphrase often used by young white women in films from the 1930s to the '60s such as *Kitty Foyle* (1940) and *The World, The Flesh and the Devil* (1959).[1] The white aggressor role dismisses the stories of racism that Pindell earnestly recounts while wrapping her head in a white bandage. The piece stands out in her practice as a departure from her earlier painterly abstraction.

The experience of being betrayed underscores the video, and the limitations of experience inform how her wounds are connected to the white bandages. The white mask, i.e. the disguise of whiteness put upon a Black person, a fair-skinned Black person of relative privilege, is a series of bandages. There is nothing she can say to the person who believes they have done her favors, and she cannot avoid betrayal. There is no dressing to undo the wounds inflicted from years of racial violence. This is an intimate violence. She must eventually come to the conclusion that she will stand in the truth of the experiences that she's had—that the violence was real, the constant abuse happened—or the attempts to co-opt what she is and what she does will continue. No one will be to blame but the victim.

In this experience that Pindell offers, she must make a stance that this shall be no more, even if she suffers, even if the opportunities fail to come, and even if they stop calling. They may start calling her undeserving. There is nothing worse than being a Black woman who thinks she deserves anything. The wounds are the only thing she will remember after her injury.

> *If you can't see this bandage on my head,*
> *if you can't see this bandage on my face,*
> *how close it is to the whiteness that you've grown accustomed to,*
> *the whiteness that allows you to believe that you own everything*
> *even your relationships, even those who do for you,*
> *then ultimately I am the fraud*
> *for allowing you to forget.*

Pindell had been recently injured at the time of the recording.[2] In an accident, a memory loss of previous injuries can be a blessing. In this case, it is a curse, as the record of her injuries is a pre-condition for her identity development. What would cause an artist who normally takes a very mathematical and calculated approach to art to put herself, her body, and her image in front of the camera, in harm's

way? Pindell allows her thoughts about racism to be identified openly, perhaps because she is always racialized openly, even with her Yale degree and abstract paintings in tow. She never had a choice in the matter, actually.

After years of serving as a curator at the Museum of Modern Art, being a gatekeeper herself, and years of coming naked to work while everyone else wears bandages and fur coats, this is her truth. She is not talking about a shared experience or the slipperiness of race and the social construct of it. She is talking about the fact of it, the lived experience, the thing that cannot be replaced by reading a book or reading an artwork.

The woman behind the camera, Maria Lino, is Latina. The woman who edited the piece, Maryann DeLeo, appears to be white. DeLeo will eventually earn an Oscar for Best Documentary Feature in 2004. The Black woman in front of the camera has given them credit. She has put their names on her piece. True to her experience, Pindell has given credit where it is due. She has not inflicted the violence of forgetting or erasing on her sister comrades in this field. She did not let the fact that they are not Black keep her from speaking her Black truth seven times, in seven different outfits, in seven shoots in their community studio in New York City.

> *Each time they have called me out of my name,*
> *each time they attempted to put me in a place that I did not belong,*
> *each time they attempted to require me to tend to their emotional space,*
> *but no more—I am free, white, and 21.*
> *The phrase used in countless classic films by white starlets.*
> *A phrase we all know, but forgot.*

RASHAYLA MARIE BROWN

1 Andrew Heisel, "The Rise and Fall of an All-American Catchphrase: 'Free, White, and 21,'" *Pictorial*, September 10, 2015, http://pictorial.jezebel.com/the-rise-and-fall-of-an-all-american-catchphrase-free-1729621311.
2 Raphael Rubinstein, "The Hole Truth," *Art in America*, October 30, 2014, http://www.artinamericamagazine.com/news-features/magazine/the-hole-truth/.

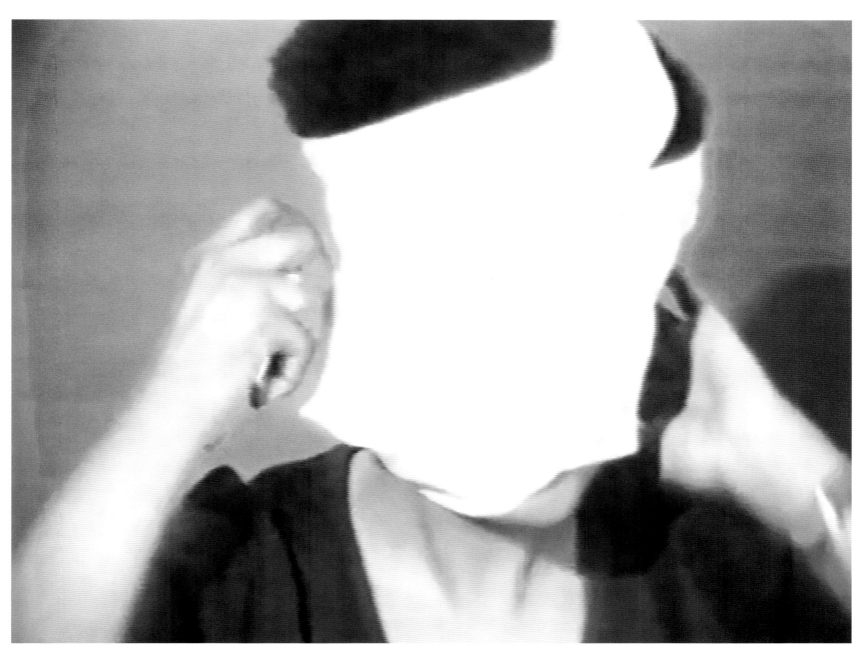

Howardena Pindell, still from *Free, White and 21*, 1980. Color video with sound, 12 minutes 15 seconds.

KELLIE ROMANY

In an effort to be held (2016) marks the newest progression in artist **Kellie Romany's** ongoing exploration of painting within a series of ceramic vessels. Over the course of her practice, Romany has become increasingly interested in ceramic forms, as their sculptural surfaces provide myriad opportunities to manipulate and experiment with paint. In 2013, Romany collaborated with ceramic artist Nicole Seisler to create a series of ethereal vessels for their installation *Gametes* at the University of Chicago's Arts Incubator. Her process here involved manipulating paint in each ceramic bowl created by Seisler, moving it around with her own hands, while observing the paint's reactions and motions.

Given their ability to hold and absorb liquid, the vessels become a new way of exploring how color can be distilled through paint—similar to Romany's works on canvas, such as *Blurred Histories* (2016), *The Only Possible Outcome* (2015), and *The Blacker the Cherry* (2016). The results in all of these works are the traces of a kind of geographical history through the course of the paint's movement—building up and eroding, stopping and careening, tightening and sagging. Through the coercion of paint, she reveals an idiosyncratic exploration of its materiality and properties, while showing the physical histories of where the paint has moved over time.

The ceramic vessels of *In an effort to be held* visually conjure abstracted bleeds, clots, rings, cracks, and rippling waveforms, as part of the artist's aim is to consider relationships between bodies, biology, and race. Romany is particularly interested in phenomena such as natural chemical reactions, the reproductive cycle, and the parts of one's genetic makeup that are not always easily seen. As she continues to experiment with paint, iterations of her work often begin to resemble more identifiable forms, from figurative representations and otherworldly topographies to more microscopic moments referencing incubation, gestation, and cell division. It is through these intimate relationships—between the abstract and the figurative, different tones of color intermixing, the artist's handling of her chosen canvas—that the paint settles into its final resting place.

Because of her favored palette of natural tones—think dirt, flesh, excrement, blood, and other bodily fluids—Romany's works have a corporeal aura, organic in both color and form. In another series, the artist uses colors inspired by the von Luschan scale, an outmoded system used to classify skin color, to paint portraits that blur the lines between figuration and non-representation.[1] Romany looks to the diversity of humankind to examine society's constantly shifting definitions of otherness, race, and beauty.

And the generosity of Romany's abstract practice lies in just how bodily her works appear. Throughout her practice, the body is represented as a permeable and evolving entity, changing over time because of the nature of the materials and the mode of application: They yellow, they darken, they wrinkle, shift, and sag. In this way, *In an effort to be held* reveals the body as something evolving and complex. Always moving, never fixed. The power in Romany's use of abstraction is as a form of liberation, a freedom to embody what is possible.

ERIN NIXON

1 Kelly Romany, in conversation with Romi Crawford at the Arts Incubator at the University of Chicago, May 19, 2013, http://www.kellieromany.com/#/gestate-installation-1/.

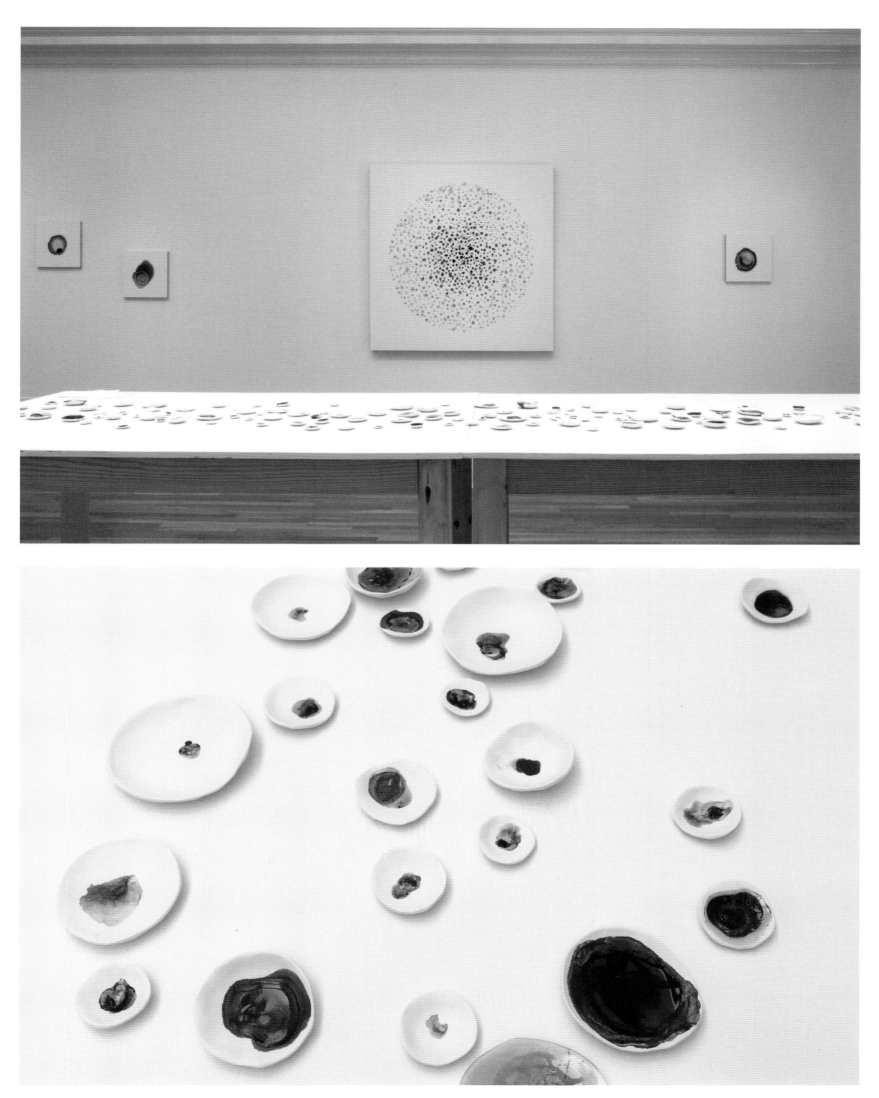

Kellie Roman, *In an effort to be held*, 2016. Oil paint and clay (300 pieces), dimensions variable.

XAVIERA SIMMONS

Working across multiple media, including photography, sculpture, installation, performance, and sound, **Xaviera Simmons** often disrupts our understanding of memory, time, and the landscape. As curator Jill Dawsey notes, "Her characters invoke a state of being between past and future identities, of being outside the established order—which is to say, a state of possibility."[1] This gesture of disruption may have been cemented during a year-and-a-half-long pilgrimage that Simmons participated in when she was 21, retracing the transatlantic slave trade. Organized by a group of Buddhist monks, the journey consisted of daily, eight-hour meditative walks. The *dérive* began in Massachusetts, made a stop in New Orleans, went on to Key West, and eventually arrived in Gambia. Simmons followed this with a year-long, self-directed tour of Africa with a friend.[2]

This formative trip laid the groundwork for the artist's continual investigations into the intersection of the landscape, the body, and the archive. Simmons' inaugural journey was a meditation on the artist's approach to history, "engag[ing] with in-between spaces, with nonlinear narratives, with narratives that drop off and then continue, with shifting landscapes and shifting narratives, shifting characters and shifting histories."[3] This shift is present in Simmons' color photograph *On Sculpture #2* (2011), in which the artist holds a black-and-white image of people jumping and diving off a boat. The dog-eared and tattered edges of the monochromatic document show that it may have been torn from a print publication. Around the edges of the color photograph, a warm turquoise sea laps at a cool blue sky. Time here is again difficult to discern. The horizon line of the black and white archival image is cleverly mapped onto that of the sea, the disruption happening across space and time. The artist's reformulation of a linear narrative into one that is rhizomatic syncopates traditional, Western, linear views of history in relation to its effects on the diaspora. In music, "syncopation" describes the shift in stress from the strong beat to the weaker one. It is an interruption of the regular beat.

In "This is the Voice of Algeria," Frantz Fanon discusses the power of these disruptions. While Fanon's argument is tied to the colonial experience—specifically the necessity of Algerians' awareness of the power of mass media—it provides a platform to consider Simmons' impulse. During the Algerian Revolution, "the Algerian…had to enter the vast network of news…to find his way in a world…in which events existed, in which forces were active."[4] In another work, *Superunknown (Alive in The)* (2010), Simmons sifts through and selects news coverage and found images of migrants traveling in nautical vessels on the water, compiling them into a grid of harrowing photographs. In a fashion similar to the ideas Fanon put forward—particularly evident in *On Sculpture #2*—Simmons experiments with the, "layering of diverse narratives and…the ways characters can be developed when you complicate a narrative of any given landscape."[5]

Visual artist and filmmaker Anri Sala has written about the presence of syncopation in contemporary art: "If we imagine the beat as a wave coming toward the shore—an event that you can see ahead of its arrival—the offbeat, by contrast, is the undertow that compensates for it, the invisible wave that pulls you offshore." The unexpected placement of Simmons' body within the composition is Sala's "invisible wave." The centering of Simmons' body within the photograph is an unexpected rupture in the dominant narrative of art history, asking the viewer to consider differing subject positions, affecting how our bodies come to understand time and their location within it.

ALLISON M. GLENN

A version of this essay was originally published on Pelican Bomb's Art Review on December 15, 2016.

1 Jill Dawsey, *salt 4: Xaviera Simmons* (Salt Lake City: Utah Museum of Fine Arts, 2011).
2 Paul Laster, "Xaviera Simmons: Beyond the Landscape," *FLATT*, accessed November 9, 2016, http://flattmag.com/features/xaviera-simmons/.
3 Cara Despain, "Surveyor. An Interview with Xaviera Simmons," *ARTPULSE*, accessed November 9, 2016, http://artpulsemagazine.com/surveyor-an-interview-with-xaviera-simmons.
4 Frantz Fanon, *A Dying Colonialism*, trans. Haakon Chevalier (New York: Grove Press, 1994), 76.
5 Despain, "Surveyor."
6 Anri Sala, "Muse: Syncopation," *Art in America*, April 1, 2016, http://www.artinamericamagazine.com/news-features/magazine/muse-syncopation/.

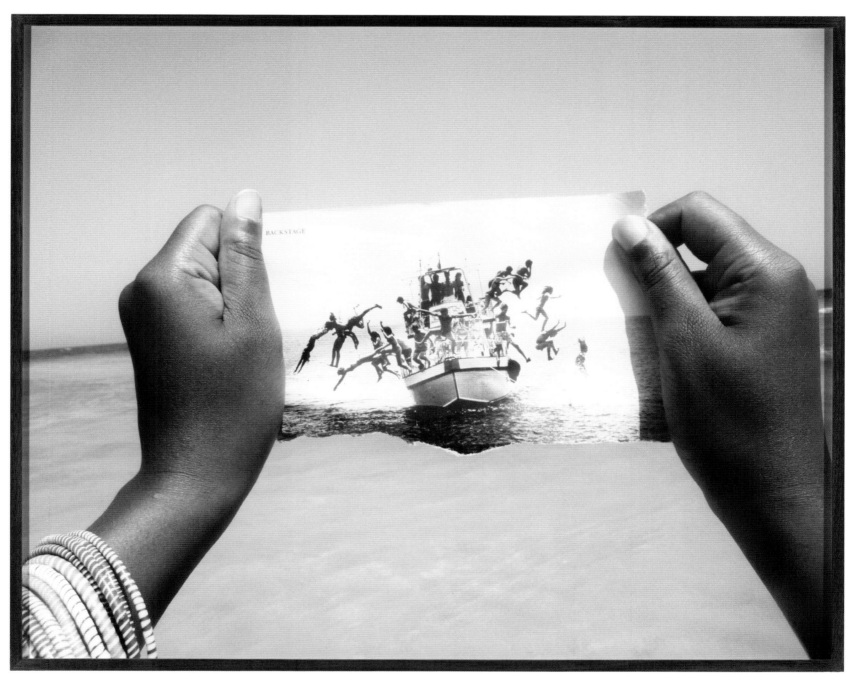

Xaviera Simmons, *On Sculpture #2*, 2011. Color photograph, 40 x 50 inches (101.6 x 127 cm).

SHINIQUE SMITH

Hoarded objects are talismans we wield against the universe. We use clothes to extend and protect our bodies in the world, layers of soft cover shielding even softer hearts. In this context, **Shinique Smith's** ever-evolving *Forgiving Strands* (2014-18) is a provocation. What began as wall-hung sketches has grown into a ceiling-mounted sculptural installation, transforming from adornment into architecture and inviting us to understand when even the heaviest of human stories begin to take flight. *Forgiving Strands* asks what it means to collect ourselves.

Forgiving Strands is a physical manifestation of cultural histories. Moving along the work, our own understanding of the narratives these patterns evoke grows according to encounter: the things we'd like to hold and the things we wouldn't. The viewer begins a process of relation through the recognition of patterns from their own life. But standard patchwork is a grid. Smith's disruption, braiding and bondage, allows us to bring together the recognizable patterns with something beyond our own memories. This is not simply a square from my baby blanket, another from my grandmother's old apron. These are bits at slant with the familiar: akin to what I recall, yet unknown and inviting. This is fabric made fleshy.

With a certain grave joy, Smith tells me that as the work changes in bulk—longer and thicker strands are added or substracted as part of *Forgiving Strands'* ongoing, adaptable site-specific nature—the density can become overwhelmingly fatter than herself. Through aggregation, soft, foldable fabrics transform into something unyielding, unbending. It's the old adage: One stick can easily be snapped, but a hundred sticks together make a blockade. Or a bridge. Or a body. The concept of forgiveness here is not forgetting but accumulating. Strength comes from acknowledging what you're asked to forgive, as well as what goes unforgiven. Challenge is an encounter with that lack of forgiveness: a certain kind of unbending. Black women in particular, this work reminds us, need to remain both soft and open to the world, unbent by the moments that break us.

Like sculpture, narrative is made of two main elements: things and composition. From there, we interpret a story. When we encounter works bigger than ourselves, this story is limited—and inspired—by our vantage point. This is important to remember: all tale-telling is shaped not only by what we can see, but also by who we are. The stories of our bodies start with our eyes and end with the experiences we carry with us. Imagination is another thing entirely: a work that begins with the investigation of others. In the tricky uncertainty of interpreting between one's self and others, both collection and abstraction can offer a protective bulk, spanning the gap between what we know and what we feel unable, or unwilling yet, to say.

A refusal to yield is not the same as a lack of understanding. Shinique Smith offers us new dimensions, from the coil to the sway. The installation moves over time from the static wall to the air, shifting from arrested manipulations to arresting kinetics. Smith's work is an invitation for us to all grow in this way. Ask me to explode my heart outwards. Ask me not to forget, but to meet my stories with yours. We make our worlds forgiving, growing together, too big to bend.

CHLOË BASS

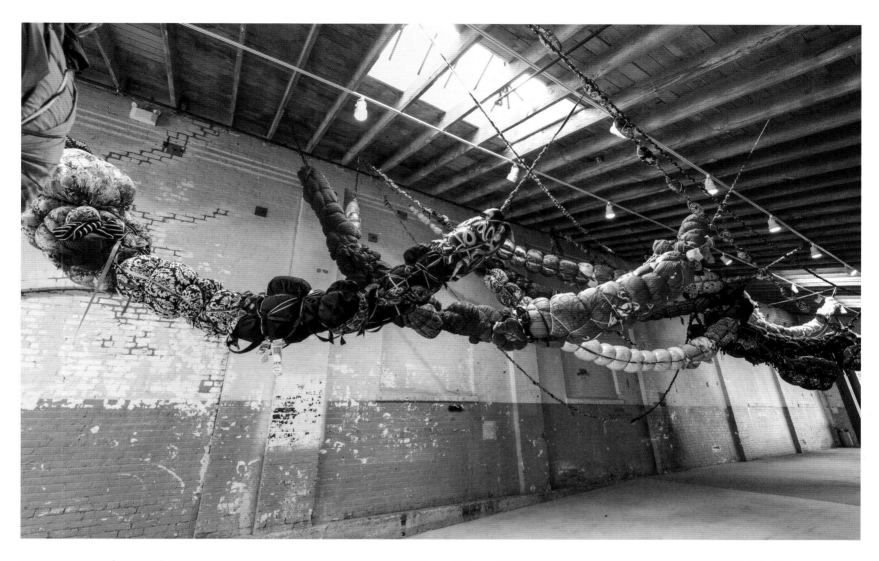

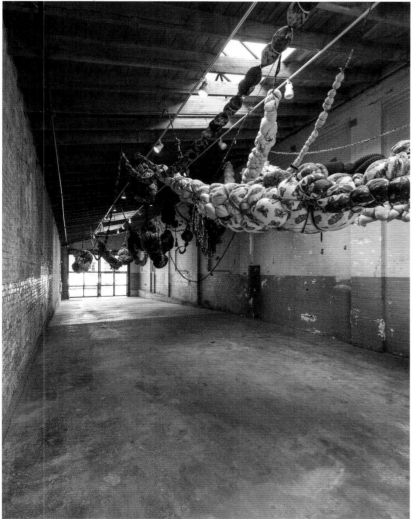

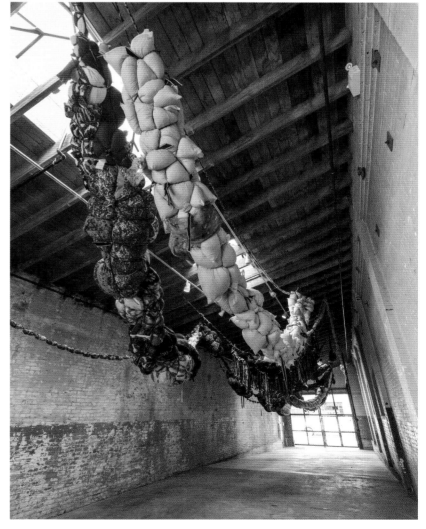

Shinique Smith, *Forgiving Strands*, 2014-18. Fabric, clothing, ribbon, rope, quilts, pillows, and accessories, dimensions variable.

EDRA SOTO

San Juan-born, Chicago-based artist **Edra Soto** often engages with her own personal history by reinventing elements of Puerto Rican culture in her work. Previous projects have seen her design domino sets and tables, craft American flags out of leaves, and upholster plastic chairs with beach towels, repurposing and recontextualizing materials and traditions from Puerto Rico and the Caribbean within a new cultural and geographic context. With *GRAFT* (2013–ongoing), Soto specifically cites the vernacular architecture of her childhood on the island, recreating the distinct patterns of metalwork commonly found on the windows, gates, and fences of middle-class homes in Puerto Rico.

Traditionally, welders have created decorative metal screens, or *rejas*, using motifs that can range from simple geometric shapes to intricate curvilinear forms, decorative versions of more austere security bars. And while Soto is careful to maintain the integrity of the metalwork's original aesthetic, her work is more translation than mimicry. For *Out of Easy Reach*, *GRAFT* is realized through linear patterns installed on the interior of DePaul Art Museum's arched windows. By using wood to represent the heavy metal gates, Soto flattens the *reja* into a planar composition. Though the patterns remain recognizable, the original function of the metal screen can only be approximated, rendering what was once utilitarian purely aesthetic. Nevertheless, *GRAFT* draws attention to the museum's glass windows, disrupting their operation as transparent, inconspicuous barriers.

Soto situates the *rejas* that inspire *GRAFT* within her larger investigation of Puerto Rico's history and colonialism, pointing to "the overlooked histories of conquest and enslavement, while hinting at a sort of neo-colonization, in which the vernacular architectural style of a colonized people is appropriated for cultural cachet."[1] The artist has come upon suggestions in some texts that the formal qualities have roots in architectural and decorative forms from Africa, presumably arriving to the island during the slave trade. Soto embraces this historical ambiguity to re-examine what might otherwise have been overlooked, ordinary objects. She further emphasizes the significance of this particular form

of vernacular architecture through an accompanying publication that features contributions by artists, sociologists, poets, and political writers.

The artist describes her *GRAFT* series as a gesture of symbolically transporting domestic architecture from Puerto Rico to the United States, noting that she would not create the same pieces on the island.[2] Instead, Soto expresses interest in contextualizing herself and her work—calling her process "a gesture that allows me to think about my presence in the United States. I don't consider it to be an opposition, fight, or gesture of violence—I think it's more presence, just planting myself."[3] In this sense, Soto's minimal lines and clean geometric forms prevent her use of domestic architecture from being simply a sentimental evocation of home. While the various iterations of *GRAFT* are each site-specific, they are unified by their separation from Puerto Rico and Soto's desire to make that distance visible.

MIA LOPEZ

1 Albert Stabler, curatorial statement for *GRAFT* at Green Lantern Press and Sector 2337, 2017.
2 "Edra Soto: Screenhouse," The Arts Club of Chicago, May 24, 2017, https://www.youtube.com/watch?v=s_p_YILt1_o.
3 Ibid.

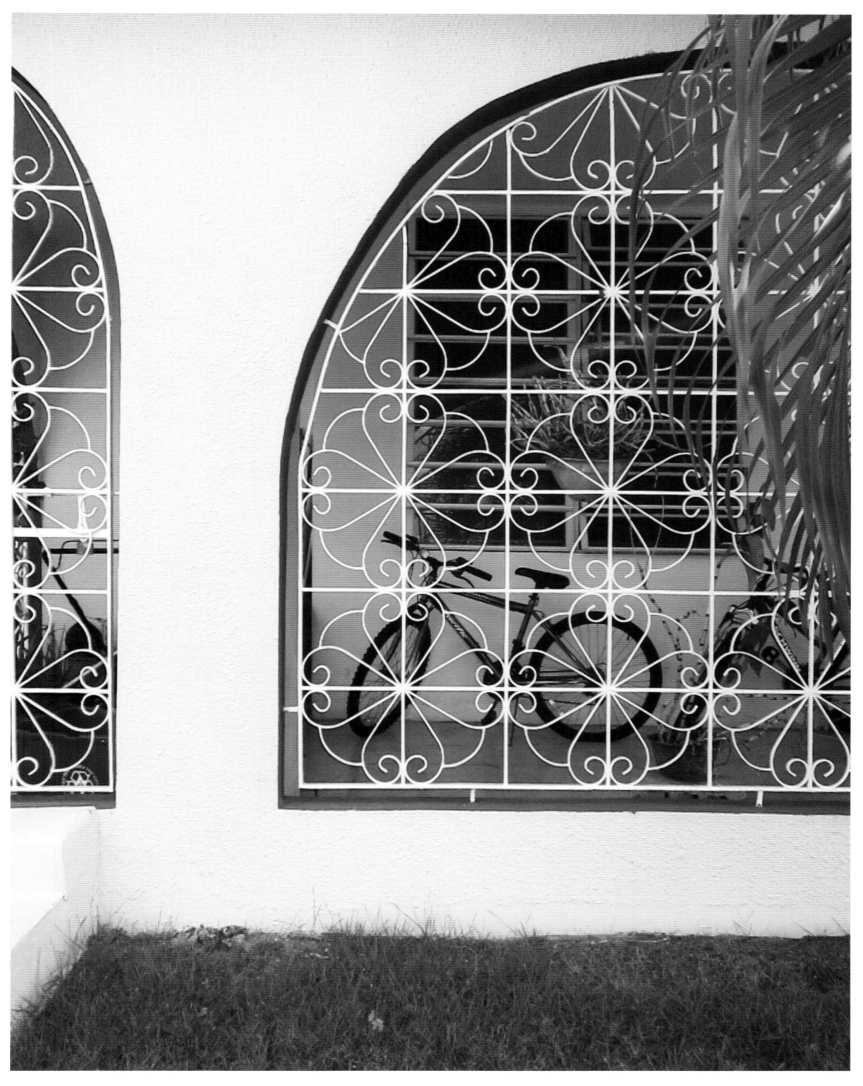

Edra Soto, photo documentation of domestic architecture from Puerto Rico, 2014-ongoing.

MARTINE SYMS

To encounter a display of **Martine Syms'** photographic installations, such as the nine prints constituting part of her series *More Than Some, Less Than Others* (2014–16), is to enter a seductive mediascape of the artist's invention. Syms, a Los Angeles-based artist, known for combining performance, video, and photography to create immersive gallery installations, uses mundane devices such as cropping, scale, and color to analyze the relationship between representations of blackness and the vernacular of screen culture.

As seen in *More Than Some, Less Than Others*, as elsewhere in her practice, Syms plays with the blackness of blackness through its abstraction as a visual sign, intonation, and a landscape of consumption and resistance.[1] Through decontextualization, revision, and arrangement, Syms confronts and unsettles visual signs by signaling towards the politicized labor of reading images. Whether it is the white block letters spelling "Los Angeles" projected onto a screen in a classroom or a business conference room; a white van parked in a grassy, seemingly abandoned lot, adorned with handwritten advertisements for body oils, black soap, socks, and towels; or a cut-off segment of a sign reading "You'll do," Syms thwarts viewers' desire for, and ability to extract or trace, a cohesive narrative among the image-text pairings. She also deploys a mixture of far-away and close-up shots to disrupt the potential for a centralized, or privileged, point of view. Instead, through the varied low-tech devices, such as projectors, hand-scribbled signage, and cut vinyl letters pictured in the series, her work extracts a bird's eye view of mediation itself. And Syms examines mediation to question her own experience of subject formation: "What does it mean for a black woman to make minimal, masculine net art? What about this piece is 'not black'? Can my identity be expressed as an aesthetic quality?"[2]

For an artist who moonlights as a "conceptual entrepreneur"—a term she coined in 2007 to encapsulate her simultaneous and contingent labor as an artist, graphic designer, and community-builder at the boutique and event space Golden Age in Chicago—it is not surprising that she seamlessly moves from discussing postmodernist cultural debates, new media, black radical feminist theory, sitcom culture, and *Goosebumps* in one breath.[3] Whereas "entrepreneur" may be viewed as a dirty word to some artists, carrying connotations of neoliberalism and the production of workers who adapt with increasing flexibility to the demands of the market-driven economy, Syms makes a point of imbuing her effusively nimble and dynamic practice with her interest in the meta-management of our hyper-mediated contemporary moment. As she makes clear in her lectures, art, and endeavors as founder of Dominica Publishing (a small press operation that publishes radical literary work), images and text exist in a racialized field of knowledge that operate as both a barrier against and tool for empowering more dynamic ways of being and knowing in relation to stereotypes and prejudice. To be a conceptual entrepreneur, it seems, is to be attuned to the interconnectedness of knowledge production and its systematization, to learn how to leverage and exploit these processes for cultural production.

The experience of passing from one seemingly disparate image to the next, which a series like *More Than Some* provides on a much larger, immersive scale, engages with the infrastructure that viewers who scroll through feeds on Instagram and Facebook have been conditioned to accept. The grouping of images in Syms' installation denaturalizes the ordering of information as neutral, inviting viewers to instead consider how the information, such as advertisements, that they encounter online has been organized by algorithms synced up to their buying habits and recent ratings—and how this funneling of preference dictates future circuits of consumption.[4] To this end, Syms' self-proclaimed interest in "the tension between conventional, segregated channels of distribution and black imagination" speaks to an investment in critiquing the standardization of consumerism that normalizes and maintains institutionalized privileges, while suspending the radical insight of black subjects shaped by, and in resistance to, hegemonic notions of preference.[5]

The graphically bold, black vinyl words against white paper in another of Syms' works, *Subtle Maneuver* (2016), makes explicit that her gestures are tactical moves to create a new space for anti-narrative within a system that celebrates smoothness and the illusion of neutrality. In this work, the text "I want to stay in the cut" implies the space of being off-center, on the margins, in the physically and conceptually blighted areas. Alternatively, in the parlance of theorist Fred Moten, the cut in music is also the generative space of radical black aesthetics and its sonic-social spatiality.[6] Within the annals of art history and visual studies, "the cut" similarly bridges the language of editing—cutting one scene and splicing it with another—and contingent histories of radical disruption: In the material incisions and the political possibilities in Romare Bearden's collages, the cut not only becomes an alternative mode for depicting representations of blackness in the United States but also embodies the possibilities for self-expression that arise when one works in and around these spaces.[7] If, by desiring to stay in the cut, Syms articulates a desire for survival, for remaining in the space of revision itself, her installations take on the stakes of an embattled territory, one shaped as much by code-switching as programmers' code—the artist's call to look carefully at and through the calibrations of our mediated social landscape as it scrolls by.

FAYE GLEISSER

1 Kevin Young, *The Grey Album: On the Blackness of Blackness* (Minneapolis: Graywolf Press, 2012). The phrase "blackness of blackness" pays homage to Kevin Young, whom Syms has cited as deeply informative for her work, often serving as a prompt or point of departure.
2 Martine Syms, "Black Vernacular: Reading New Media," public lecture at SXSW Interactive, March 2013, http://martinesyms.com/black-vernacular-reading-new-media/.
3 Emily McDermott, "The Conceptual Entrepreneur," *Interview*, December 29, 2015, http://www.interviewmagazine.com/art/martine-syms-16-faces-of-2016.
4 See Felix Salmon, "Netflix's dumbed-down algorithms," *Reuters*, January 3, 2014, http://blogs.reuters.com/felix-salmon/2014/01/03/netflixs-dumbed-down-algorithms/. For further reading, Salmon discusses here how "implicit preference" shapes the cue of recommended movies on Netflix.
5 Syms, "Black Vernacular."
6 Fred Moten, *In the Break: The Aesthetics of the Black Radical Tradition* (Minneapolis: University of Minnesota Press, 2003), 223.
7 Kobena Mercer, "Romare Bearden, 1964: Collages as Kunstwollen," in *Cosmopolitan Modernisms*, ed. Kobena Mercer (Cambridge, Massachusetts: MIT Press, 2005), 124-145.

Martine Syms, *Subtle Maneuver X*, 2016. Cut vinyl on paper, 28 x 22 inches (71.1 x 55.9 cm).

ZIPPORAH CAMILLE THOMPSON

Zipporah Camille Thompson's *panspermiatic drift* and *prismatic root* (both 2015) are representative of her practice of fusing together an array of materials and techniques to connect histories both personal and collective. Evocative of Thompson's deeply intuitive material process, the works evidence both the metaphysical and spiritual by way of abstraction.

The ethos of Thompson's practice is to explore universal concepts of understanding and meaning-making. Much of her inspiration is derived from landscapes and landforms, either physical and tangible or imagined and unknown. A material investigation of natural disasters and their ability to shape our environment, *panspermiatic drift* derives from the artist's examination of various media images of major floods. Instead of focusing on moments of disaster and destruction, she channels the conditions immediately following. Using hand-weaving and tapestry methods, Thompson fuses color-saturated fabric, wool, and plastic to evoke eroded, glistening soil, permeated with random detritus and the material aftermath of the flood. The work's amorphous structure holds a tangle of barely recognizable materials and objects metaphorically washed up from human civilization, yet the sculpture rejects exact identification and worldly representation.

In *prismatic root*, Thompson's taxonomic collection of objects explores the act of accumulation, redefining the mundane as sacred. The work matches natural and synthetic human hair with wool and fur from animals—in an exploration of the spirituality of hair and its power to cover and protect both human and animal species. Arranged like anthropological specimens, hair becomes a lens through which a multitude of forcefully defined identities and experiences can transcend the limits of a singular understanding of race, gender, and sexuality. This collection prompts the viewer to consider notions of identity, self, and otherness through material objects. The ambiguity of the hair and its exact significance also allows viewers to enter the work in their own ways; the objects exude a sense of power, but the specific interpretation of that power is left open-ended.

Thompson's practice transfigures found materials and her spiritual experiences of landscape into investigations of self and identity, both for herself and the viewer. The resulting multifaceted forms are simultaneously the artist's responses to the sensual properties of the material world and explorations of metaphysical landscapes around her. The transformation of the materials becomes a kind of ritual exercise for Thompson. Her process allows a bit of chance into the work as she immediately and intimately responds to various colors, surfaces, and textures. For the artist, these various object rituals become lessons in hybridity, mindfulness, and fluidity.

panspermiatic drift and *prismatic root* both use processes of abstraction as a form of alchemy to alter and transform ordinary and traditional ways of viewing reality into new mental spaces that exist beyond what one readily sees and experiences. Thompson suggests this type of transformation is especially necessary for marginalized populations as a form of self-care and liberation—a process artist Mark Bradford describes as "an alchemy about hope."[1] In Thompson's view, this hope is universal, and by way of abstraction, it has the power to change, transform, and uplift humanity.

ERIN NIXON

1 Jane Ure-Smith, "Mark Bradford on his US pavilion at the Venice Biennale," *Financial Times*, May 5, 2017, https://www.ft.com/content/a9554e82-2b49-11e7-bc4b-5528796fe35c.

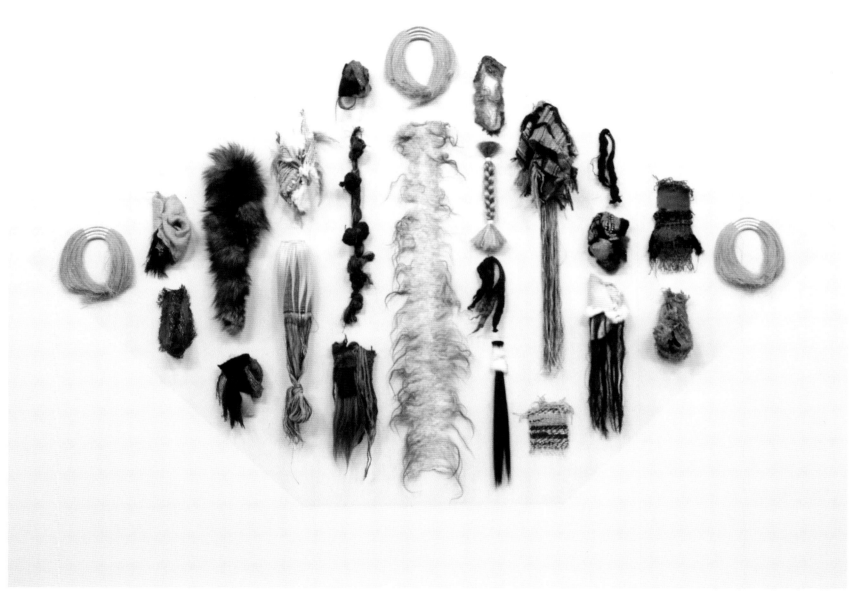

Zipporah Camille Thompson, *prismatic root*, 2015. Acrylic and mixed media, 70 x 70 x 7 inches (177.8 x 177.8 x 17.8 cm).

BRENNA YOUNGBLOOD

Brenna Youngblood's painting-objects come out of traditions ranging from René Magritte's 1939 Surrealist semiotic riddle "Ceci n'est pas une pipe" and Robert Rauschenberg's politically charged combine paintings to Noah Purifoy's assemblages, Mark Bradford's large-scale abstractions, and the fastidious compositions of Henri Cartier-Bresson. Odds and ends from her studio, the detritus of everyday life, and other found objects become formal and symbolic elements in the enigmatic paintings that complicate the representation of ideas, images, bodies, and objects.

Although the paintings are seemingly abstract, Youngblood often attaches used items on their surfaces—for example, cigarette butts, wallpaper, air fresheners, a dollar bill, a plastic shopping bag, a beer carton—transforming them into formal elements once their use-value has expired. (Occasionally a collaged photograph makes its way into a painting, and when it does, it's an image that Youngblood has shot on film and printed herself.[1]) These pieces of everyday life are placed within the paintings, whose heavily worked surfaces[2] often have an eroded, rusty, or worn appearance, creating what the artist has called "a metaphor for degraded America."[3]

One of Youngblood's most reductive works is an untitled painting from 2012, which channels a Russian Constructivist aesthetic by way of the artist's Downtown Los Angeles studio. In fact, with this work, she set out to see how minimally she could bring together objects to create a successful painting. A pre-primed four-by-three-foot white canvas (matching the proportions of a 35mm negative) sets the ground for a grimy, ripped piece of wrinkled paper placed near the top of the canvas. Just below, another smaller rectangle is formed by the bottom of a 30-pack of beer on which the circular imprint of the cans has created a repeating geometric pattern. Using a repurposed olive-oil sprayer from the restaurant supply store located on the ground floor of her studio building, Youngblood spray-painted the tab of a Budweiser beer can, which is affixed to the lower left corner of the crinkled paper, and a thin rivulet of blood-red paint interrupts the white field

in a diagonal line descending to the left edge of the painting. The bodily crimson evokes both beauty and horror—a purposeful disruption to the surface that underscores the artist's hand in composing the work, the imperfect quality of the other materials, and the autobiographical experiences and memories embedded in the found objects.

Youngblood eschews pictorial representation in order to complicate what it means to convey the complexity of one's own experiences, resisting the flattening of collective representation. As viewers, we are invited into her experience through the familiar everyday objects that surround her, and now us; she states, "Something poetic and existential emerges from a common-signifier—something that we see every day."[4] The ambiguity of Youngblood's work further offers a space for a viewer's subjectivity and memory to dance around her symbols, pointing to commonality rather than difference.

JULIE RODRIGUES WIDHOLM

1 Brenna Youngblood, personal conversation, June 20, 2017.
2 Rosanna Albertini, "Not Only for Looking At: Interviews with Brenna Youngblood and Dawn Kasper," *Flash Art*, September 2013. Youngblood further states, "Surface is and has always been integral to my practice. The transformation of the surface of my paintings mimics objects, materials, and textures from the real world, (i.e. rusted metal, wood)."
3 Brenna Youngblood, personal conversation.
4 Albertini, "Not Only for Looking At."

Brenna Youngblood, *Untitled*, 2012. Mixed media on canvas, 48 x 36 x 3 inches (121.92 x 91.44 x 7.62 cm).

CONTRIBUTORS

RACHEL ADAMS is Senior Curator of Exhibitions for the University at Buffalo Art Galleries. Adams holds an M.A. in Exhibition and Museum Studies from the San Francisco Art Institute and a B.F.A. from the School of the Art Institute of Chicago. Recently, she curated *Wanderlust: Actions, Traces, Journeys 1967-2017*, a 50-year survey of artists performing in the landscape and the first solo museum exhibition in the U.S. of the Brazilian-born artist Lydia Okumura.

CHLOË BASS is a conceptual artist working in performance, publications, and installation. Her work addresses scales of intimacy and looks to daily life as a site of deep research. Her projects have appeared in recent exhibitions at CUE Art Foundation, New York; Elizabeth Foundation for the Arts Project Space, New York; and the Southeastern Center for Contemporary Art, Winston-Salem. Bass lives and works in Brooklyn and is an Assistant Professor in Art at Queens College, CUNY.

RASHAYLA MARIE BROWN works across photography, performance, writing, drawing, installation, and video art. Her work has been shown at the Museum of Contemporary Art, Chicago; Museum of Contemporary Photography, Chicago; INVISIBLE-EXPORTS, New York; University of Pennsylvania, Philadelphia; and the Museum of the African Diaspora, San Francisco; and her writing has been published in *Artforum*, *Modern Painters*, *Chicago*, *Hyperallergic*, and *Nka: Journal of Contemporary African Art*. Brown is currently a doctoral student in Performance Studies at Northwestern University.

TORKWASE DYSON describes herself as a painter interested in spatiality, environmental justice and form. Her work has been exhibited at the Studio Museum in Harlem, New York; the Whitney Museum of American Art, New York; the Drawing Center, New York; and the National Museum of African Art, Washington, D.C. Dyson has been awarded grants and fellowships from the Joan Mitchell Foundation, the Nicholas School of the Environment at Duke University, and the Nancy Graves Foundation.

ALEXANDRIA EREGBU is a visual artist, curator, and educator. Her work interrogates familial, ancestral, and collective traumas, with the intent of moving toward a more vibrant and harmonious future. Eregbu's work has been featured in exhibitions at Weinberg/Newton Gallery, Roots & Culture, the Arts Incubator at the University of Chicago, and Hyde Park Art Center, all in Chicago, IL; The Luminary, St. Louis; Milwaukee Art Museum; the Distillery Gallery, Boston; and Pioneer Works, Brooklyn. Eregbu received her B.F.A. from the School of the Art Institute of Chicago in 2013.

FAYE GLEISSER is a freelance curator and Assistant Professor of Art History at Indiana University. Her research focuses on articulations of race and gender in contemporary art and urbanism. She is currently writing a book manuscript that examines the entangled histories of artists' deployment of guerrilla tactics and criminal code reform in the United States during the 1970s.

ALLISON M. GLENN is Associate Curator of Contemporary Art at Crystal Bridges Museum of American Art. She was previously Manager of Publications and Curatorial Associate for Prospect New Orleans' international art triennial *Prospect 4: The Lotus in Spite of the Swamp*. Her writing has been featured in exhibition publications for the Los Angeles County Museum of Art; Prospect New Orleans; the California African American Museum; University at Buffalo Art Galleries; and the Studio Museum in Harlem; and she has contributed to *ART21 Magazine*, *Hyperallergic*, Pelican Bomb's Art Review, and *Newcity*. Glenn received dual Master's Degrees from the School of the Art Institute of Chicago in Modern Art History, Theory, and Criticism and Arts Administration and Policy and a Bachelor of Fine Art Photography with a co-major in Urban Studies from Wayne State University in Detroit.

MIA LOPEZ is Assistant Curator at DePaul Art Museum in Chicago. She was previously Curatorial Fellow for Visual Arts at the Walker Art Center in Minneapolis. Lopez has dual Master's Degrees in Art History and Arts Administration from the School of the Art Institute of Chicago and a bachelor's degree in Art History from Rice University in Houston. She is an alumna of the Smithsonian Latino Museum Studies Program and the National Association of Latino Arts and Culture Leadership Institute.

KIMIA MALEKI graduated with an M.A. in Arts Administration and Policy at the School of the Art Institute of Chicago. She curated "Islamic Art at the Art Institute of Chicago: A Century of Exhibitions and Acquisitions" and "Sedentary Fragmentation" at Heaven Gallery, Chicago. She has held positions at Stony Island Arts Bank, the School of the Art Institute of Chicago, and the Persepolis Fortification Archive at the Oriental Institute of the University of Chicago.

ERIN NIXON is Assistant Director at Gallery 400 at the University of Illinois at Chicago. She was a co-curator of *Extinct Entities*, which explored histories of Chicago-based art spaces and collectives and was an organizer for the Chicago Underground Film Festival and the Onion City Film Festival. She currently co-curates *Channels: A Quarterly Film Series*, which hosts screenings at venues throughout Chicago. She received her M.A. in Arts Administration & Policy from the School of the Art Institute of Chicago.

JULIE RODRIGUES WIDHOLM is Director and Chief Curator of DePaul Art Museum where she leads the strategic and artistic vision to promote equity and interdisciplinary education in the arts, while positioning Chicago as a global art city. Her work seeks to expand the canon by providing a platform for marginalized practices, voices and experiences.

CAMERON SHAW is a writer, an editor, and Executive Director of Pelican Bomb in New Orleans. Her work at Pelican Bomb centers on developing platforms for diverse voices, particularly through publishing and exhibition-making, to expand the ways individuals and communities interact with contemporary art. Her writing frequently engages with the legacy of African-American art and image practices since 1960 and has been widely published including in *The New York Times*, *Art in America*, *Los Angeles Review of Books*, and *BOMB Magazine* and in books on Marcel Dzama, Chris Ofili, Tameka Norris, Nick Cave, and other artists. Shaw was awarded a Creative Capital/Andy Warhol Foundation Arts Writers Grant for Short-Form Writing in 2009 and was selected as a Robert Rauschenberg Foundation Writing Fellow in 2015.

LORELEI STEWART has been Director and Curator of Gallery 400 at University of Illinois at Chicago since 2000. Her work focuses on the vital role art plays in shaping civic conversations, ideas, and ultimately actions. In 2005 her exhibition *Edgar Arceneaux: The Alchemy of Comedy...Stupid* won the Joyce Award. She teaches in UIC's Museum and Exhibition Studies program and co-founded Propeller Fund, which, since 2010, has awarded Chicago artists nearly half a million dollars.

EMILY WILKERSON is a New Orleans-based writer and curator. She was Deputy Director for Curatorial Affairs for *Prospect 4: The Lotus in Spite of the Swamp*. Wilkerson has worked on exhibitions and projects at the San Francisco Museum of Modern Art, the Chinati Foundation, PARSE NOLA, and the Contemporary Arts Center New Orleans. She received a Master's Degree from the University of Southern California, Los Angeles, in Art and Curatorial Practices in the Public Sphere and holds a Bachelor of Arts from Louisiana State University in Baton Rouge.

JENNIFER M. WILLIAMS was Deputy Director for the Public Experience for *Prospect.4: The Lotus in Spite of the Swamp*. From 2009-2016, Williams was Director & Curator of the McKenna Museum of African-American Art, New Orleans. She is an alumna of Georgia State University and has also led discussions on economic inequities in New Orleans and around the world, including at Dak'Art in Senegal and at New York's Urban Bush Women Summer Leadership Institute.

ALLISON YOUNG is currently the Andrew W. Mellon Foundation Fellow for Modern and Contemporary Art at the New Orleans Museum of Art. She received her Ph.D. in Art History in 2017 from New York University with her dissertation "'Torn and Most Whole': On the Poetics of Difference in the Art of Zarina Bhimji." Young has taught courses at Parsons School of Design, New York, and is a contributor to Artforum.com, *ART AFRICA*, and *Apollo*.

CHECKLIST OF WORKS

DEPAUL ART MUSEUM

CANDIDA ALVAREZ
chill, 2011
Oil, pencil, enamel, acrylic on canvas
84 x 72 inches (213.36 x 182.88 cm)
Courtesy of the artist

BETHANY COLLINS
Southern Review, 1985 (Special Edition), 2014–15
Charcoal on paper (64 pieces)
57 1/2 x 104 inches (146.05 x 264.16 cm) overall
Collection of Eugene Fu

ABIGAIL DEVILLE
I am invisible, understand, simply because people refuse to see me from *Nobody Knows My Name*, 2015
Two CRT TVs, mirrored glass, archival photographs from the Vivian G. Harsh Research Collection of Afro-American History and Literature, epoxy, mirror mastiff
43 x 41 x 22 inches (109.22 x 104.14 x 55.88 cm)
Courtesy of the artist and Monique Meloche Gallery, Chicago

MAREN HASSINGER
Fight the Power, 2016
Ink on paper
20 x 35 x 5 inches (50.8 x 88.9 x 12.7 cm)
Courtesy of the artist

ARIEL JACKSON
The Origin of the Blues, 2015
High-definition video with sound
3D compositing by Godfrey Hibbert
4 minutes, 17 seconds
Courtesy of the artist

STEFFANI JEMISON
Same Time, 2016
Acrylic on polyester film
101 7/8 x 20 inches (258.7625 x 50.8 cm)
Courtesy of the artist

Same Time, 2016
Acrylic on polyester film
20 x 72 inches (50.8 x 182.88 cm)
Courtesy of the artist

JENNIE C. JONES
Gray Measure with Clipped Tone (Inverses), 2016
Acoustic absorber panel and acrylic paint on canvas
Left part: 12 x 36 inches (30.5 x 91.4 cm)
Right part: 24 x 24 inches (61 x 61 cm)
Courtesy of the artist and Sikkema Jenkins & Co., New York

CAROLINE KENT
First you look so strong, Then you fade away, 2015
Acrylic on unstretched canvas
108 x 72 inches (274.32 x 182.88)
Courtesy of the artist

Procession, 2015
Acrylic on unstretched canvas
108 x 72 inches (182.88 x 274.32)
Courtesy of the artist

AYANAH MOOR
Good News, 2011
Silkscreen on paper (24 pieces)
24 x 36 inches each (60.96 x 91.44 cm)
Courtesy of the artist

KELLIE ROMANY
In an effort to be held, 2016
Oil paint and clay (300 pieces)
Dimensions variable
Courtesy of the artist

XAVIERA SIMMONS
On Sculpture #2, 2011
Color photograph
40 x 50 inches (101.6 x 127 cm)
Engel/Feldman Family Collection, Chicago

EDRA SOTO
GRAFT, 2018
Site-specific installation on DePaul Art Museum façade
Courtesy of the artist

BRENNA YOUNGBLOOD
Untitled, 2012
Mixed media on canvas
48 x 36 x 3 inches (121.92 x 91.44 x 7.62 cm)
Collection of Scott J. Hunter, Chicago

GALLERY 400

LISA ALVARADO
Traditional Object 21, 2017
Acrylic, fabric, and wood
86 x 104 inches (218.4 x 264.2 cm)
Courtesy of the artist and Bridget Donahue, New York

Traditional Object 15, 2014
Acrylic, fabric, and wood
74 x 80 inches (188 x 203.2 cm)
Courtesy of the artist and Bridget Donahue, New York

TORKWASE DYSON
Untitled (Hypershape), 2017
100 gouache and pen on paper drawings
12 x 9 inches (30.5 x 22.3 cm) each
Courtesy of the artist and Rhona Hoffman Gallery

LESLIE HEWITT
Riffs on Real Time (10 of 10), 2008
Traditional chromogenic print
40 x 30 inches (101.6 x 76.2 cm)
Collection of Dr. Daniel S. Berger, Chicago

JULIANA HUXTABLE
Nuwaub Chair, 2012
Color inkjet print
8 x 10 inches (20.32 x 25.4 cm)
Courtesy of the artist and JTT, New York

Untitled (For Stewart), 2012
Color inkjet print
20 x 30 inches (50.8 x 76.2 cm)
Courtesy of the artist and JTT, New York

Untitled (Destroying Flesh), 2015
Color inkjet print
40 x 30 inches (101.6 x 76.2 cm)
Courtesy of the artist and JTT, New York

Untitled (Casual Power), 2015
Color inkjet print
40 x 30 inches (101.6 x 76.2 cm)
Courtesy of the artist and JTT, New York

YVETTE MAYORGA
Monument 1, 2015
Frosting, foam, plaster, party decorations, toy soldiers, guns, hair, balloons, wood, fabric, acrylic, and handcuffs
48 x 12 x 12 inches (121.9 x 30.5 x 30.5 cm)
Courtesy of the artist

Monument 2, 2015
Frosting, foam, plaster, party decorations, toy soldiers, Selena's picture, guns, hair, balloons, wood, fabric, acrylic, and handcuffs
30 x 24 x 24 inches (76.2 x 61 x 61 cm)
Courtesy of the artist

Monument 3, 2015
Frosting, foam, plaster, party decorations, toy soldiers, guns, hair, balloons, wood, fabric, acrylic, and handcuffs
24 x 6 x 24 inches (61 x 15.24 x 61 cm)
Courtesy of the artist

Monument 4, 2015
Frosting, foam, plaster, party decorations, toy soldiers, guns, hair, balloons, wood, fabric, acrylic, and handcuffs
48 x 12 x 12 inches (121.9 x 30.5 x 30.5 cm)
Courtesy of the artist

Monument 5, 2015
Frosting, foam, plaster, party decorations, toy soldiers, Selena's picture, guns, hair, balloons, wood, fabric, acrylic, and handcuffs
72 x 30 x 30 inches (182.9 x 76.2 x 76.2 cm)
Courtesy of the artist

HOWARDENA PINDELL
Free, White and 21, 1980
Color video with sound
12 minutes, 15 seconds
Courtesy of the artist and Garth Greenan Gallery, New York

MARTINE SYMS
More Than Some, Less Than Others VIII, 2014–16
Archival pigment print
28 x 22 inches (71.1 x 55.9 cm)
Courtesy of the artist and Bridget Donahue, New York

More Than Some, Less Than Others IX, 2014-2016
Archival pigment print
28 x 22 inches (71.1 x 55.9 cm)
Courtesy of the artist and Bridget Donahue, New York

More Than Some, Less Than Others X, 2016
Archival pigment print
28 x 22 inches (71.1 x 55.9 cm)
Courtesy of the artist and Bridget Donahue, New York

More Than Some, Less Than Others XII, 2016
Archival pigment print
28 x 22 inches (71.1 x 55.9 cm)
Courtesy of the artist and Bridget Donahue, New York

More Than Some, Less Than Others XVI, 2014–16
Archival pigment print
28 x 22 inches (71.1 x 55.9 cm)
Courtesy of the artist and Bridget Donahue, New York

More Than Some, Less Than Others XIX, 2014–16
Archival pigment print
28 x 22 inches (71.1 x 55.9 cm)
Courtesy of the artist and Bridget Donahue, New York

More Than Some, Less Than Others XXII, 2014–16
Archival pigment print
28 x 22 inches (71.1 x 55.9 cm)
Courtesy of the artist and Bridget Donahue, New York

More Than Some, Less Than Others XXVII, 2014–16
Archival pigment print
28 x 22 inches (71.1 x 55.9 cm)
Courtesy of the artist and Bridget Donahue, New York

More Than Some, Less Than Others XXXIX, 2016
Archival pigment print
28 x 22 inches (71.1 x 55.9 cm)
Courtesy of the artist and Bridget Donahue, New York

Subtle Maneuver X, 2016
Cut vinyl on paper
28 x 22 inches (71.1 x 55.9 cm)
Courtesy of the artist and Bridget Donahue, New York

ZIPPORAH CAMILLE THOMPSON
prismatic root, 2015
Acrylic and mixed media
70 x 70 x 7 inches (177.8 x 177.8 x 17.8 cm)
Courtesy of the artist and Whitespace Gallery, Atlanta

panspermiatic drift, 2015
Handwoven tapestry
44 x 26 x 12 inches (111.8 x 66 x 30.5 cm)
Courtesy of the artist and Whitespace Gallery, Atlanta

STONY ISLAND ARTS BANK
BARBARA CHASE-RIBOUD
Little Gold Flag, 1985
Polished bronze, silk
78 x 26 x 15 inches (198.1 x 66 x 38.1 cm)
Courtesy of the artist and Michael Rosenfeld Gallery, New York

SHEREE HOVSEPIAN
Reveries of a Solitary Walker, 2015
Archival dye transfer, graphite, acrylic, silver gelatin prints, wood, ink drawing on paper, brass nails, string
50 x 40 inches (127 x 101.6 cm)
Courtesy of the artist and Monique Meloche Gallery, Chicago

Peaking, 2015
Ink and walnut oil on paper
85 1/2 x 58 1/2 x 1 1/4 inches (217.2 x 148.6 x 3.2 cm)
Courtesy of the artist and Monique Meloche Gallery, Chicago

Sway, 2017
Unprocessed photographic paper, silver gelatin photogram, nylon, artist-made frame
37 1/4 x 25 1/4 x 4 inches (94.6 x 64.1 x 10.2 cm)
Courtesy of the artist and Monique Meloche Gallery, Chicago

Lotus Position, 2017
Silver gelatin photograms, nylon, artist-made frame
31 1/4 x 25 1/4 x 5 inches (79.4 x 64.1 x 12.7 cm)
Courtesy of the artist and Monique Meloche Gallery, Chicago

Form Body, 2017
Silver gelatin photograms, nylon, artist-made frame
31 1/4 x 25 1/4 x 5 inches (79.4 x 64.1 x 12.7 cm)
Courtesy of the artist and Monique Meloche Gallery, Chicago

CHECKLIST OF WORKS (CONTINUED)

SHINIQUE SMITH
Bale Variant No. 0022, 2012
Clothing, fabric, objects, wrapping paper, ribbon
90 x 30 x 30 inches (228.6 x 76.2 x 76.2 cm)
Collection of Jack and Sandra Guthman, Chicago

Forgiving Strands, 2014-18
Fabric, clothing, ribbon, rope, quilts, pillows, keepsakes, accessories
Scale Variable
Courtesy of the artist and David Castillo Gallery, Miami

LENDERS TO THE EXHIBITION

Bridget Donahue Gallery, New York
David Castillo Gallery, Miami
Dr. Daniel S. Berger, Chicago
Engel/Feldman Family, Chicago
Garth Greenan Gallery, New York
Eugene Fu, Chicago
Jack and Sandra Guthman, Chicago
JTT, New York
Michael Rosenfeld Gallery, New York
Monique Meloche Gallery, Chicago
Rhona Hoffman Gallery, Chicago
Scott J. Hunter, Chicago

PROJECT TEAM

DEPAUL ART MUSEUM
Julie Rodrigues Widholm
Laura-Caroline Johnson
Mia Lopez
Kaylee Wyant

GALLERY 400, UNIVERSITY OF ILLINOIS AT CHICAGO
Lorelei Stewart
Erin Nixon
Demecina Beehn
Erin Madarieta
Rachel McDermott
Megan Moran
Marcela Torres

STONY ISLAND ARTS BANK
Theaster Gates
Carris Adams
Elly Hawley
Mallory McClaire
Pete Skvara
Maya Wallace
G'Jordan Williams
Chris Salmon
Sonia Yoon

COPY EDITOR
Charlie Tatum

IMAGE CREDITS

LISA ALVARADO
Image courtesy of the artist

CANDIDA ALVAREZ
Image courtesy of the artist. © Tom Van Eynde

BARBARA CHASE-RIBOUD
Image courtesy of the artist and Michael Rosenfeld Gallery, New York

BETHANY COLLINS
Image courtesy of PATRON, Chicago

ABIGAIL DEVILLE
Images courtesy of the artist and Monique Meloche Gallery, Chicago

TORKWASE DYSON
Image courtesy of the artist and Rhona Hoffman Gallery, Chicago

MAREN HASSINGER
Image courtesy of the artist. © Kim Dacres

LESLIE HEWITT
Image courtesy of the artist and Galerie Perrotin, Paris

SHEREE HOVSEPIAN
Images courtesy of the artist and Monique Meloche Gallery, Chicago

JULIANA HUXTABLE
Images courtesy of the artist

ARIEL JACKSON
Image courtesy of the artist

STEFFANI JEMISON
Image courtesy of the artist and NurtureArt, Brooklyn. © NurtureArt, Brooklyn

JENNIE C. JONES
Image courtesy of the artist and Sikkema Jenkins & Co., New York. © Jason Wyche

CAROLINE KENT
Image courtesy of the artist. © Renee Yamada

YVETTE MAYORGA
Image courtesy of the artist

AYANAH MOOR
Image courtesy of the artist.

HOWARDENA PINDELL
Images courtesy of the artist and Garth Greenan Gallery, New York

KELLIE ROMANY
Images courtesy of the artist. © Kelly Kristen Jones

XAVIERA SIMMONS
Collection Museum of Contemporary Art Chicago, restricted gift of Emerge, in memory of Andree Stone, 2012.17. Photo: Nathan Keay, © MCA Chicago

SHINIQUE SMITH
Image courtesy of the artist and David Castillo Gallery

EDRA SOTO
Image courtesy of the artist

MARTINE SYMS
Image courtesy of the artist and Bridget Donahue, New York

ZIPPORAH CAMILLE THOMPSON
Image courtesy of the artist and Whitespace Gallery, Atlanta

BRENNA YOUNGBLOOD
Image courtesy of Honor Fraser Gallery, Los Angeles